MARY
McCARTNEY
FROM
WHERE
I
STAND

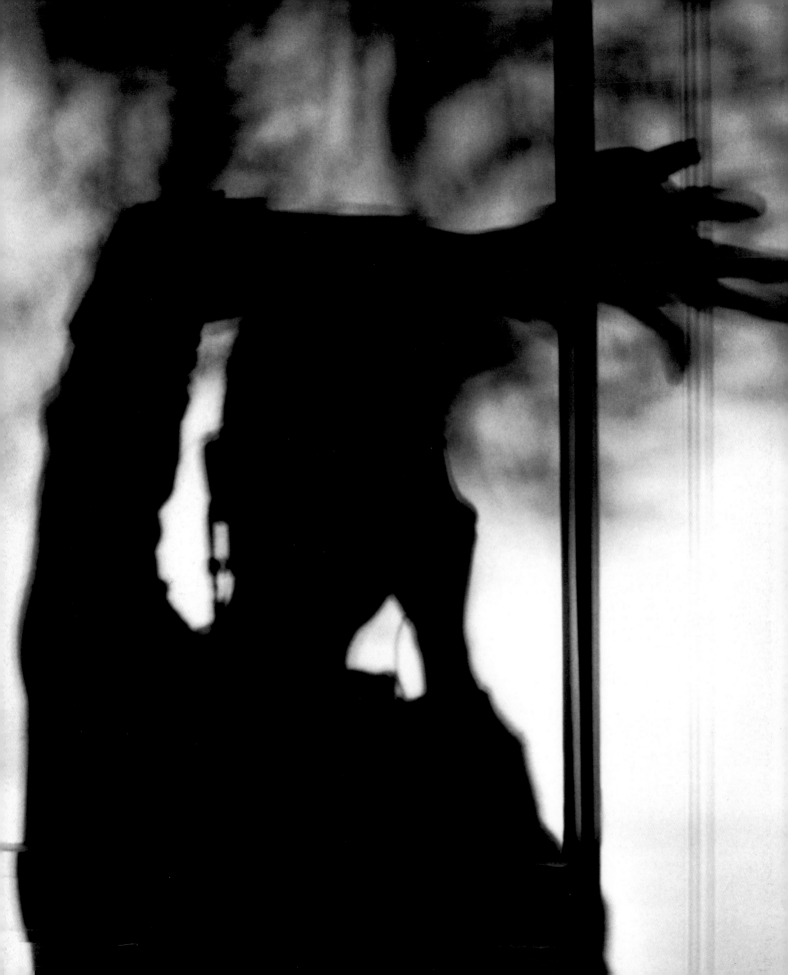

MARY McCARTNEY

FROM WHERE I STAND

WITH TEXTS BY MARY McCARTNEY, SIMON ABOUD,
PETER BLAKE, CHRISSIE HYNDE AND PAUL McCARTNEY

ABRAMS, NEW YORK

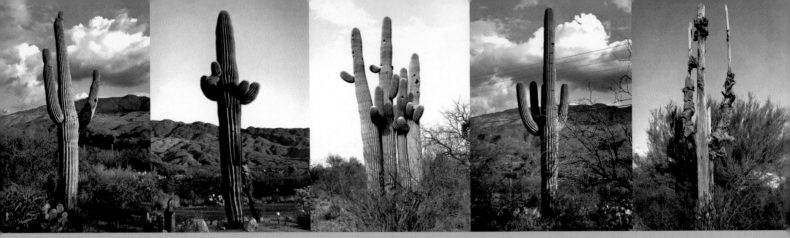

For my family x

Page 2: Self-portrait, 2005.

Above and opposite: Arizona, 2003.

Library of Congress Cataloging-in-Publication Data:
McCartney, Mary.
 Mary McCartney : from where I stand / Mary McCartney.
 p. cm.
 ISBN 978-0-8109-9654-0 (alk. paper)
1. Celebrities—Portraits. 2. Artists—Portraits. 3.
Entertainers—Portraits. 4. Photography, Artistic. I. Title. II. Title:
From where I stand.
 TR681.F3M394 2010
 779'.2092—dc22
 2010016356

First published in the United Kingdom in 2010 by Thames and Hudson Ltd,
181A High Holborn, London WC1V 7QX.

Published in the United States of America in 2010 by Abrams, an imprint of
ABRAMS. All rights reserved. No portion of this book may be reproduced,
stored in a retrieval system, or transmitted in any form or by any means,
mechanical, electronic, photocopying, recording, or otherwise, without
written permission from the publisher.

Printed and bound in China
10 9 8 7 6 5 4 3 2 1

Abrams Books are available at special discounts when purchased in quantity
for premiums and promotions as well as fundraising or educational use.
Special editions can also be created to specification. For details, contact
specialmarkets@abramsbooks.com or the address below.

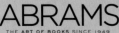

THE ART OF BOOKS SINCE 1949
115 West 18th Street
New York, NY 10011
www.abramsbooks.com

CONTENTS

MARY McCARTNEY: My life has never really been about structure. I think this freedom has always been a theme for my photography. We travelled a lot with our parents – nomadic, happy wanderings. One of my friends used to say I was like a 'peace convoy' child. I took that as a compliment, as it summed up the rather laid-back nature of it all. Being on the move, you gather impressions of multiple places, people and events. Unlikely to see these things again, you retain the mental image, embellish it even. Such images framed my upbringing, while the photographic images that I saw were by an inspirational photographer: my mother.

Like many, I used the camera to hide behind, and to develop and discover the world I was faced with. It has given me the ticket to be in social situations without socializing, invaluable when photographing musicians and actors. More importantly, it has taught me to look for different angles. I have never been happy just to be in front of the subject, lighting precisely and then shooting frame after frame. This process seems to me designed rather than captured. I prefer to trace things back: models backstage, dancers at home, off guard and visually vulnerable. Images present themselves spontaneously, images that give the viewer an insight into an experience, a career, a life.

From Where I Stand embodies the way I see things. I would never claim this was unique, but it is deeply personal. I am at my happiest when I have the time to know my subject and to capture the moment that sums up my knowledge of them. In that way, the photos I have taken over the years

Self-portrait, Nashville, 2004

of Sir Peter Blake and Chrissie Hynde satisfy me greatly. The time we spend together is so rewarding. They let me into their worlds and, in doing so, they seem effortlessly to fall into mine. I don't go into the shoot with visual concepts; the images are co-authored – co-inspired – in the moment by the sitter and myself. This thrills me, every time. If you can capture it, that is what makes a photograph require repeat viewing.

This book is also about my view of the world as influenced by my family. I have included photographs of them as my greatest supporters and as examples of the sitters I know and love most of all. It was difficult to find favourites, there are so many. It is their belief and support, especially that of my father and mother, that have carried me forward for so long.

SIMON ABOUD: I have watched Mary take photographs countless times. It's unavoidable as she carries a camera everywhere – it's a fundamental part of what she does and the way she looks at the world. There is an easiness to it all that I particularly like, an effortlessness from her which, in turn, makes the whole scientific interaction effortless. Many people don't like having their photo taken but I suspect most of Mary's sitters are thrilled by just how painless the process has been. I have wondered how she does that.

She has great skills, no doubt. A great eye, an ability to create the right composition and a necessary relationship with technology. But Mary also has the ability to leave her own ego out of an image. She has the confidence to let the subject fill all four corners of the frame and I think only the very good can do that, it's instinctive. The results reflect an individual, not a style.

I love the images of the corps de ballet backstage in London, and how Mary got inside their lives. They are joyous, captured by someone who let them be, finding tiny moments that give such rich and deep emotion. Mary is still friends with all the dancers. This should come as no surprise.

The book seamlessly glides between family and work, between portraits and pure observation. Its images all have the same approach from a photographer who can let her subjects unknowingly stamp their personality all over the negative, and who observes the world by standing in a slightly different, and rather wonderful, place.

Simon Aboud, writer, director and Mary McCartney's husband, London, 2007

SIR PETER BLAKE: I think that you could say that we are 'friends of the family' – the McCartney family that is. The first time I met Mary's father Paul was when the Beatles did their first London television programme in 1962.

As a consequence I have watched the McCartney children grow up and followed their careers with interest. As a photographer Mary has continued the intimate record of family life that was begun by her mother Linda with such beautiful pictures of the family at work and play.

I suppose that in a way Mary was privileged to inherit the ultimate AAA (Access All Areas) pass to go backstage in the music world. But she has proceeded far beyond that now and has quietly and gently earned the right to photograph behind the scenes in the height of the worlds of fashion, ballet and art, capturing wonderful, intimate photographs and making many friends along the way.

Mary and I have worked together often. It is her I call when I need a new photograph, and it's always a picture by Mary that I send for when a photograph is requested.

Mary has visited my studio a number of times, sometimes at my request and other times to take pictures for her portfolio. These visits are always a lot of fun. One time we played with my hat collection and she took a picture of me in the Robin Hood hat which was worn by Douglas Fairbanks in the 1922 film. We plan to take a set of photographs of me wearing more of my collection of hats. I completely trust Mary in my studio. I think she loves the various collections and I know she will always be discreet. But most importantly I enjoy her company and look forward to her visits, knowing that we will always have a good time.

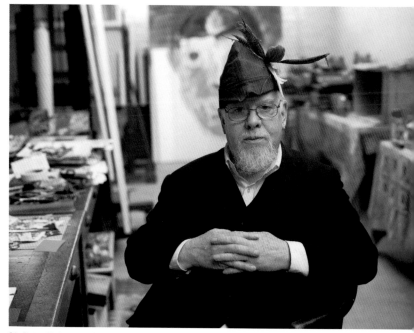

Sir Peter Blake wearing Douglas Fairbanks's hat from the 1922 film *Robin Hood*, London, 2007

In 2009 I was asked by Sport Relief to choose a sportsman to make a portrait of, to be auctioned for the charity. I commissioned Mary to take photographs of boxer Ricky Hatton which I then worked from to paint the portrait. We met at a gymnasium where a number of fighters had gathered to train and to meet Ricky. Mary was completely at ease in the rough, male environment and got some fantastic pictures.

This is a wonderful book that takes us into a world we rarely see: her family, backstage at the ballet and at fashion shows, and, of particular interest to me, the art world.

Thank you Mary, it has been a privilege and an enormous pleasure to share your world and your personal vision.

CHRISSIE HYNDE: Like everyone else my age, I first saw Mary peeking out from inside her dad's jacket on the cover of Paul McCartney's first solo album. That picture of course was taken by her mother, Linda McCartney. The candid, intimate and casual nature of that photo was typical of Linda, and Mary, it transpires, has turned out to be her mother's daughter.

You won't find a gaggle of stylists, make-up artists and props at a Mary McCartney shoot. Her photos are not staged or manipulated. She seems to be looking – searching for the moments when her target is most off-guard. Rather than create a composition, she seems to be seeking the composition within – to portray the character of the subject rather than define it.

I think you could say, at the expense of possibly losing her a job or two, that Mary is the opposite of a fashion photographer. She doesn't seem to have a taste for taste-making. Like Linda, she is very mindful of making everyone around her, especially her subjects, as comfortable as she can. No one's on display. But having said that, her photos of models being made up are the most beautiful fashion shots I've seen.

When I invited her round once to take some publicity pics of me, she was most happy to shoot me wielding a neighbour's chainsaw. I'm not sure if that's what the record company had in mind, but Mary indulged me as if I was slinging a Telecaster about, no problem.

The personality and essence of her subject are indeed what come through in her work. A weather-beaten window frame. The ears of the horse she's riding and the field beyond. A mystery blonde sleeping naked under a crumpled sheet. When a photographer is as in awe of the simple moment as Mary, even the mundane can reveal its eternal nature – that moment when the beauty of an ordinary gesture is captured and laid bare, to be revisited over and over.

I myself have been regrettably vocal over the years regarding my dislike of being photographed. I have not been good at trying to project a favourable image. I am of the school of thought that the camera steals. But in the case of Mary's work, I would have to say, *au contraire*, her pictures 'offer' something to the subject. No matter how humble or grand that subject might be, Mary gives it the dignity to be itself.

Chrissie Hynde, London, 2003

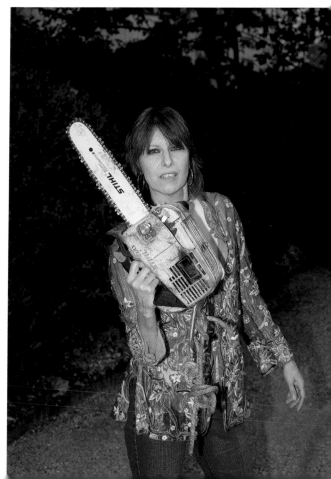

SIR PAUL McCARTNEY: Growing up in our family, Mary was never far away from a camera and at an early age she began to show a keen interest in photography. I'm sure that watching her mum work gave her many insights into the process and it was no surprise to us when she ultimately chose photography as a career.

I believe there are three main requirements for a photographer to take a great picture. First, to be in the right place at the right time. Secondly, to know what to look for and focus on. Thirdly, it's vital to click at the right moment.

If you think about classic photographs such as Henri Cartier-Bresson's famous picture of a man jumping over a puddle, all these requirements were satisfied – he was there, he knew what to focus on and he clicked at the right time. I believe that in her own way Mary fulfils these criteria, and this shows clearly in the images contained in her book.

It is also important for a photographer to have a well developed sense of what is beautiful and, if possible, a sense of humour. Again, this is also apparent in her work and I'm proud to have been asked to write these words for this fine volume of photographs.

More than all this, I am very excited to see what an impressive book Mary has put together. As her father, I am more than proud of what she has achieved already and it is with all my love that I wish her all the best for the future.

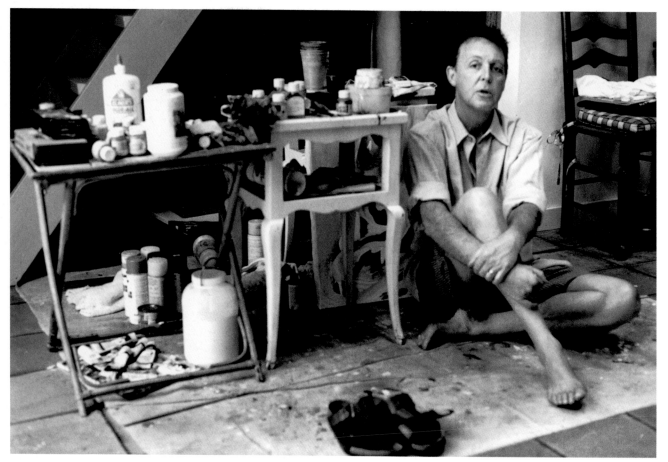

Dad, Long Island, 2000

THE PHOTOGRAPHS

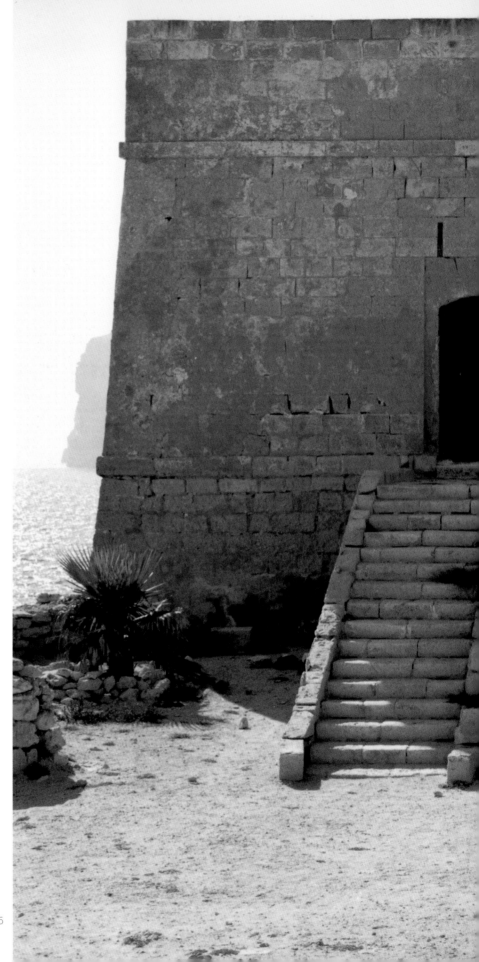

Gozo, Malta, 2005

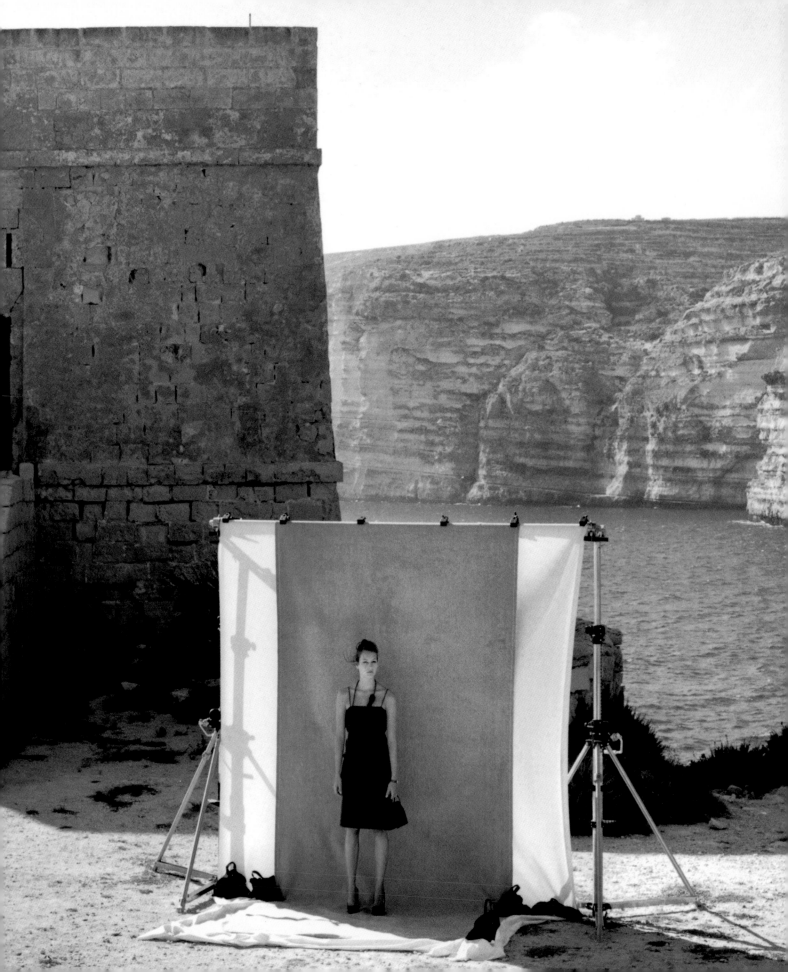

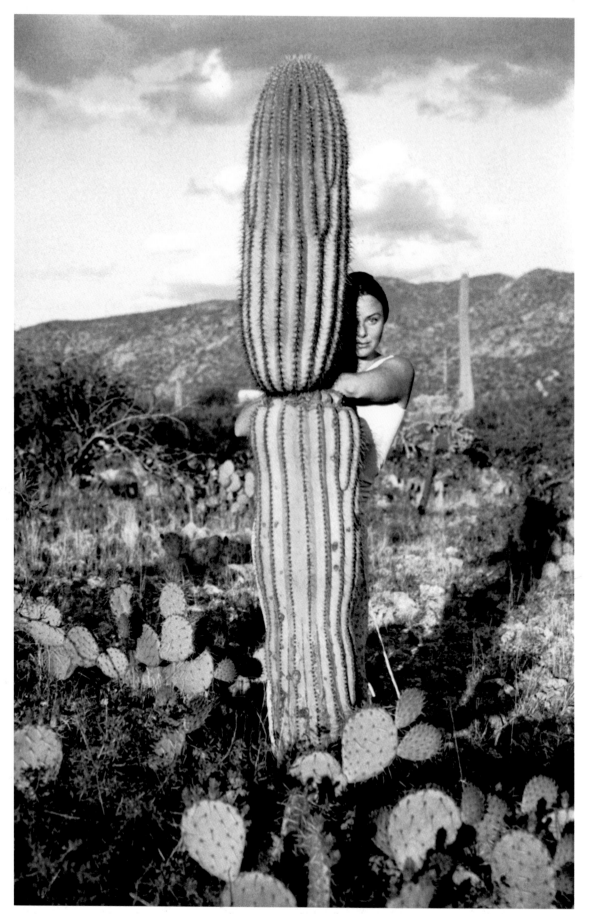

Stella, Arizona, 1995

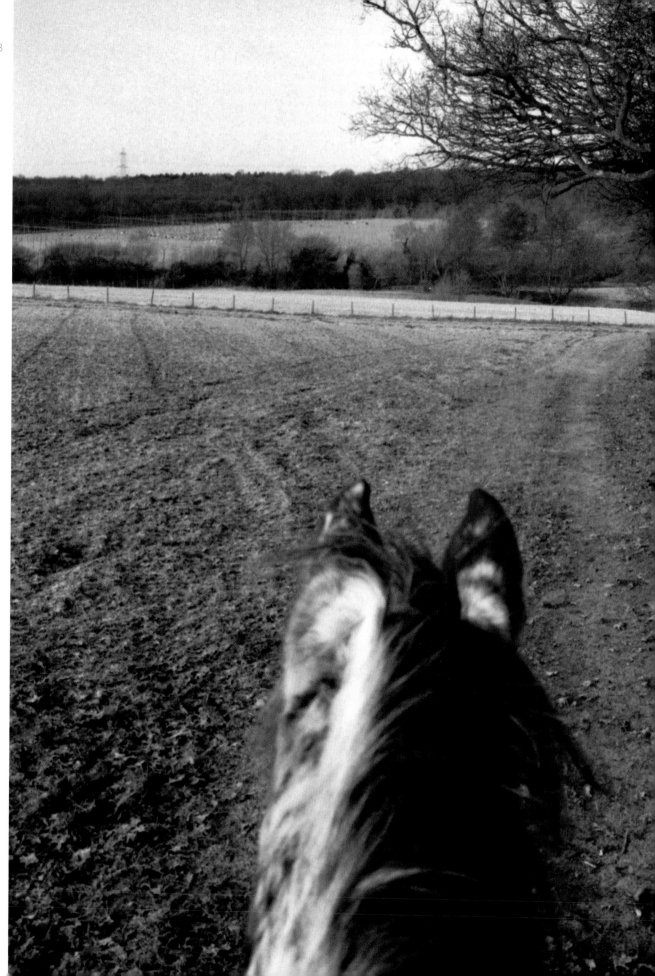

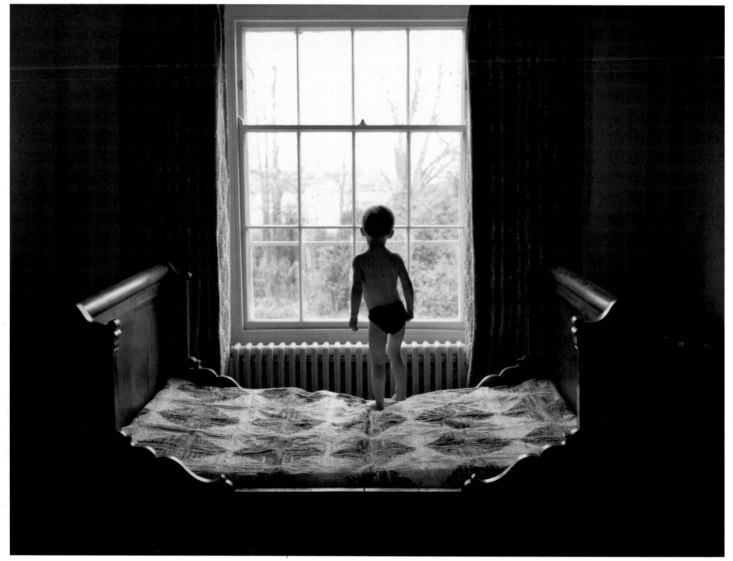

Worcestershire, 2005

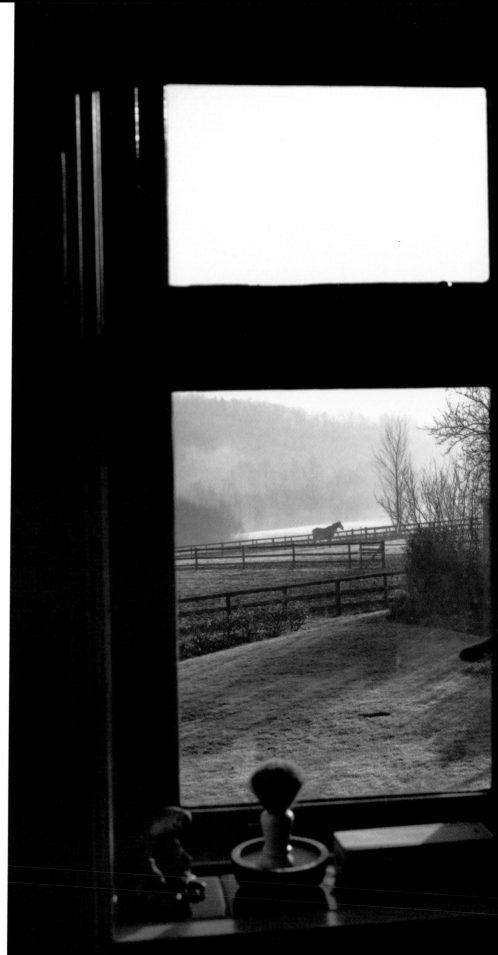

Sussex, 1996

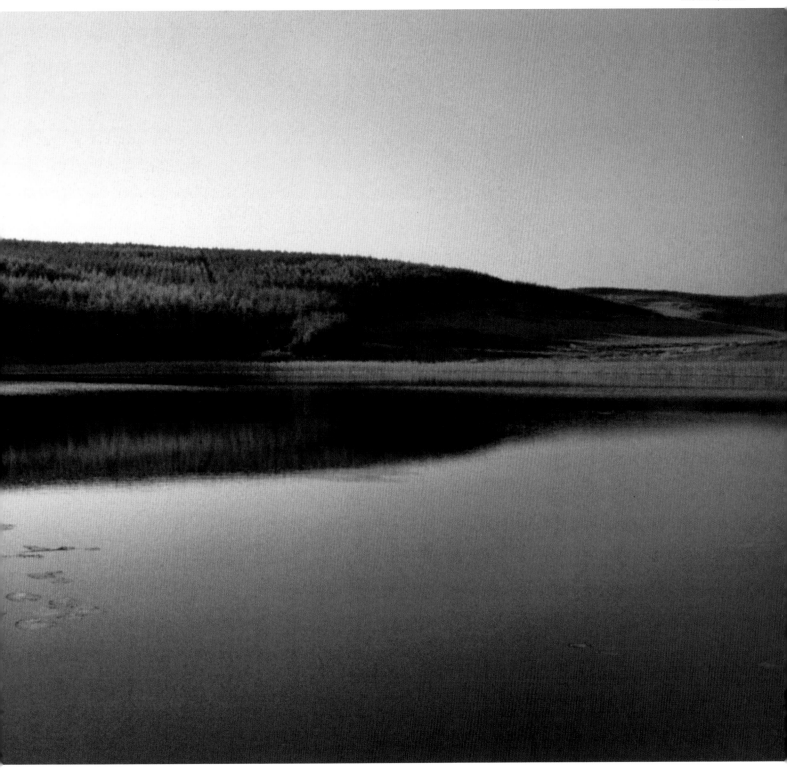

Mum and Dad, Scotland, 1995

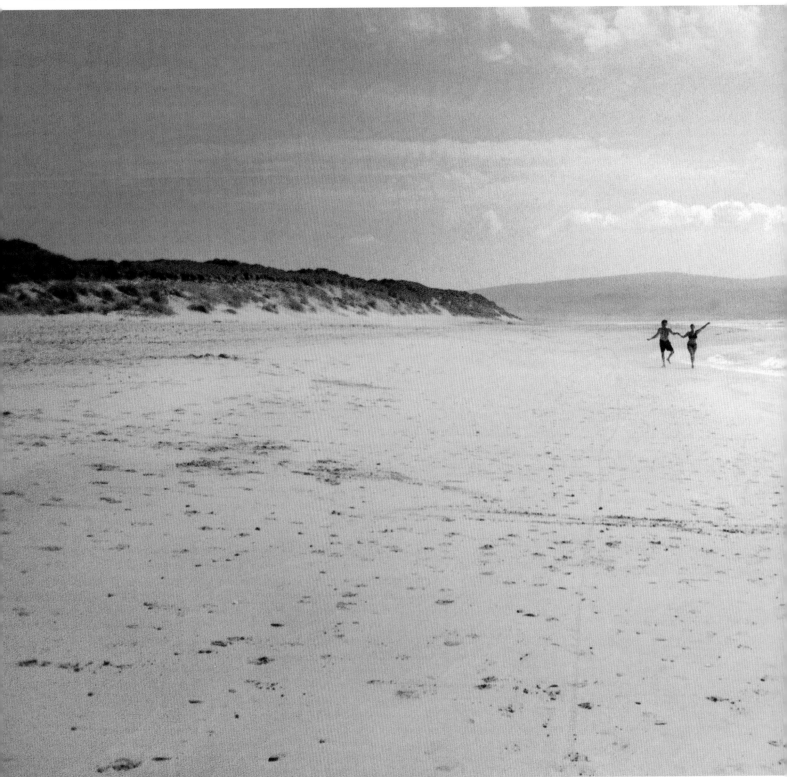

Sian Murphy, London, 2004

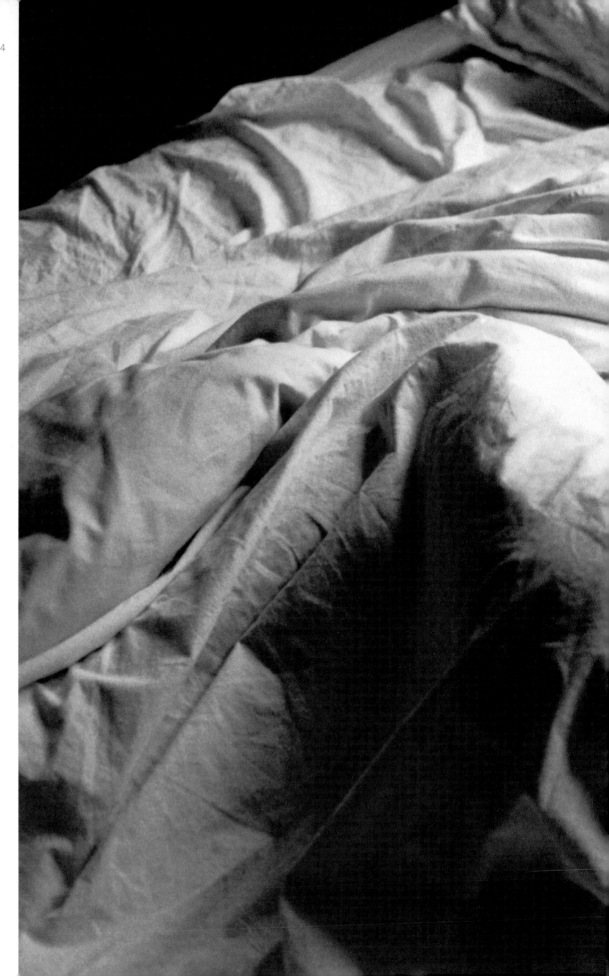

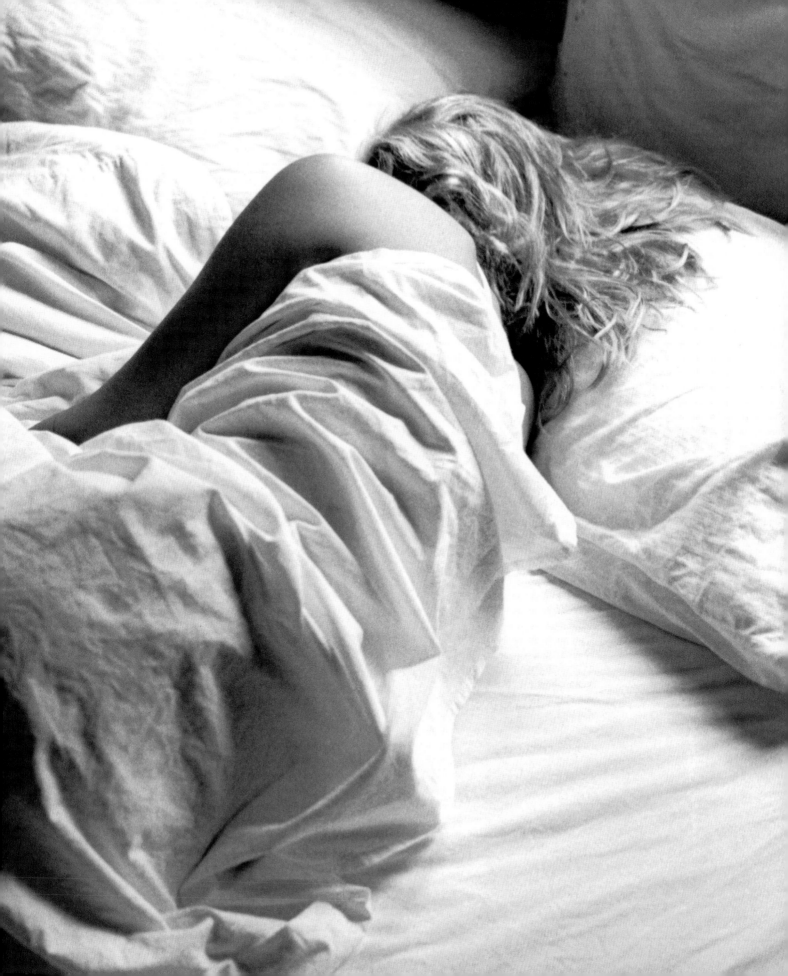

"

I like the stories
that beds tell,
the imprints
of memories,
of safety
and peace.

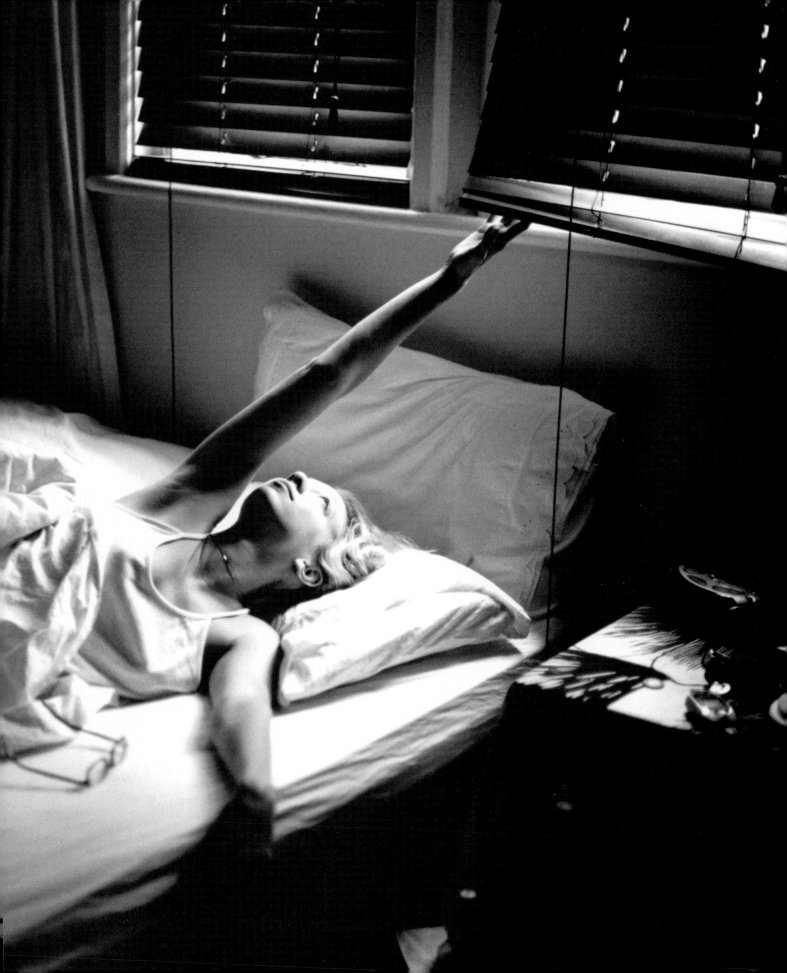

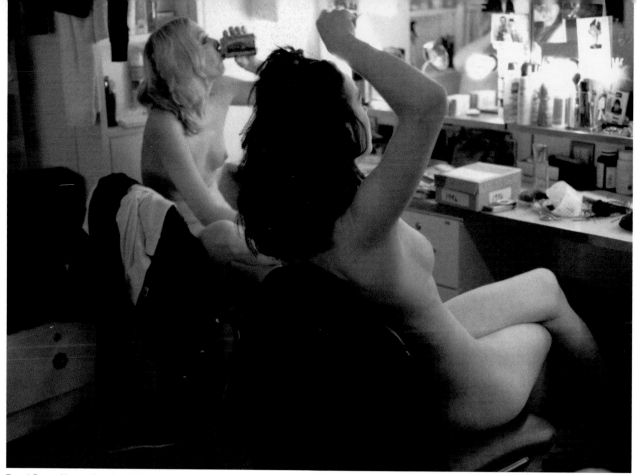

Royal Opera House, London, 2004

Royal Opera House, London, 2004

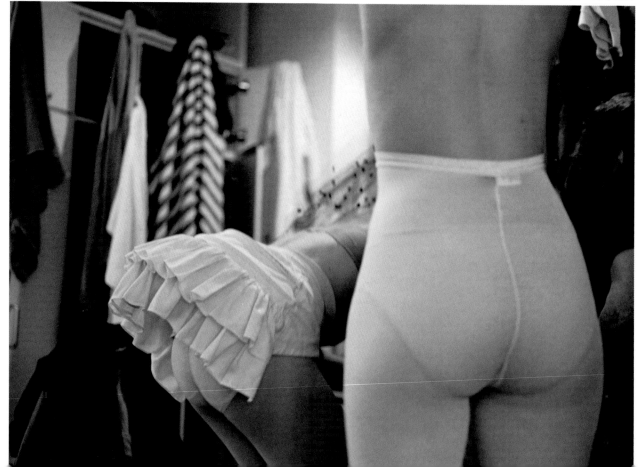

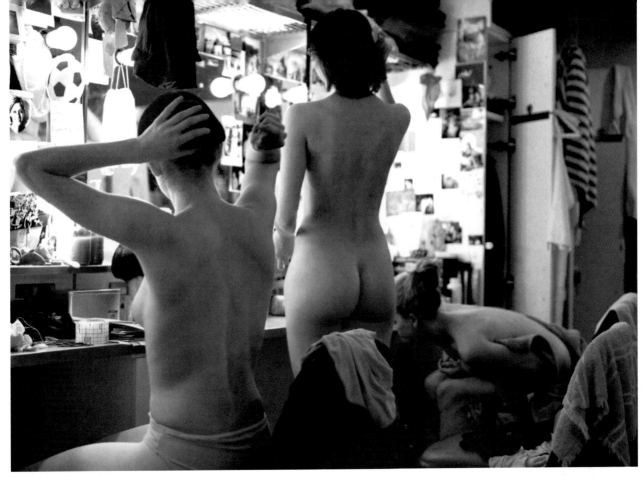

Royal Opera House, London, 2004

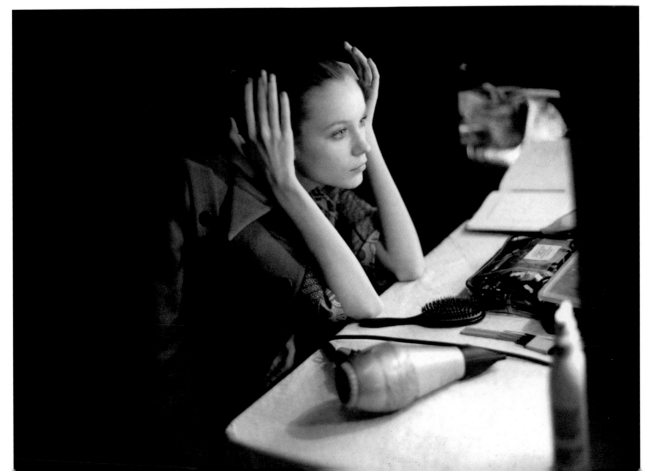

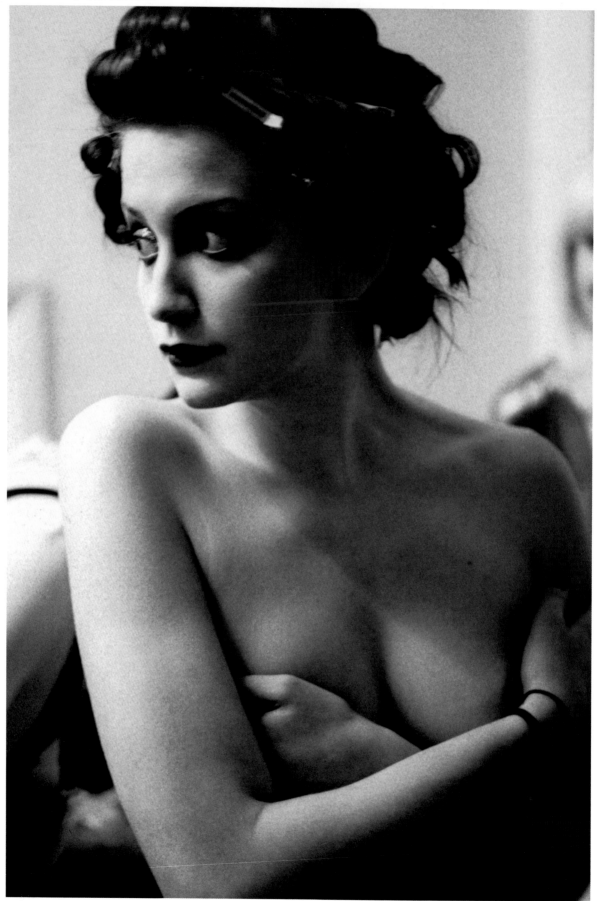

OPPOSITE Josh Tuifua, Royal Opera House, London, 2004

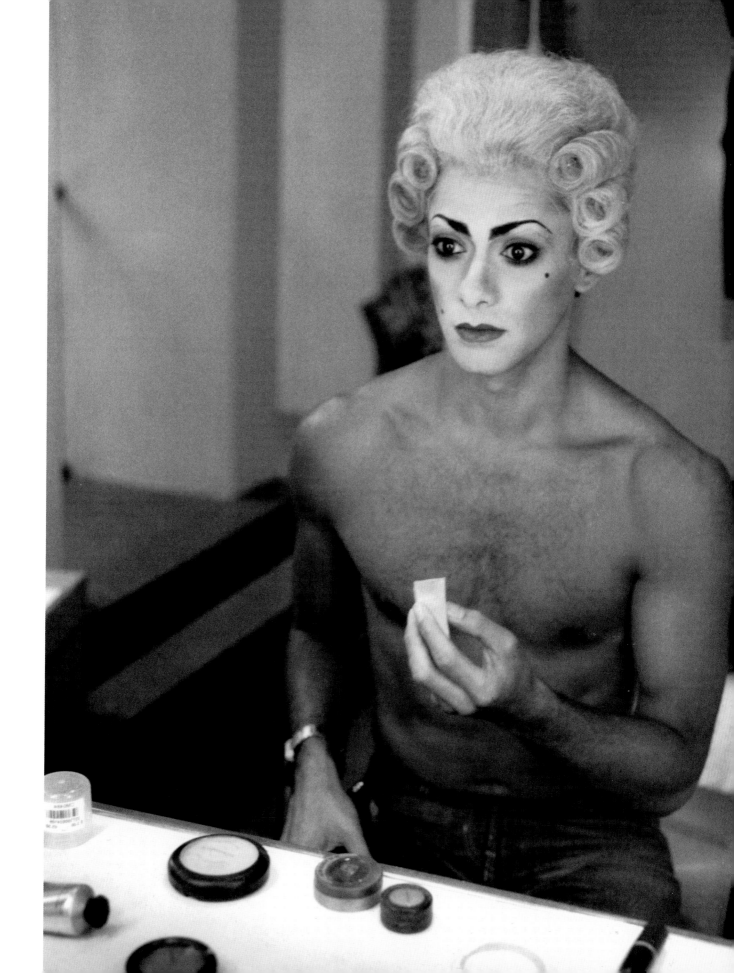

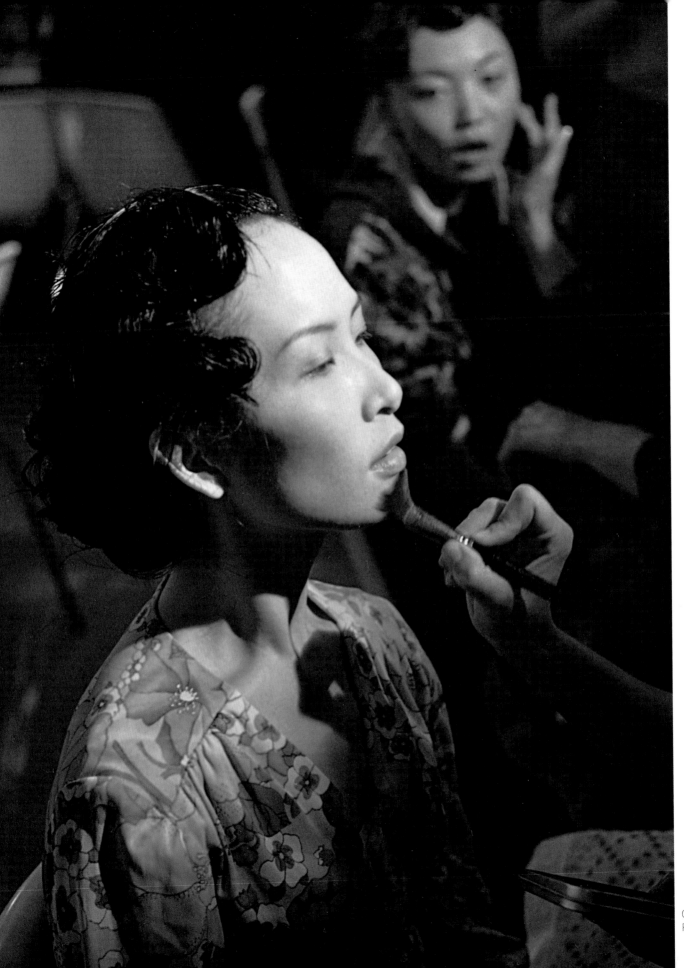

Chloé Show,
Paris, 2007

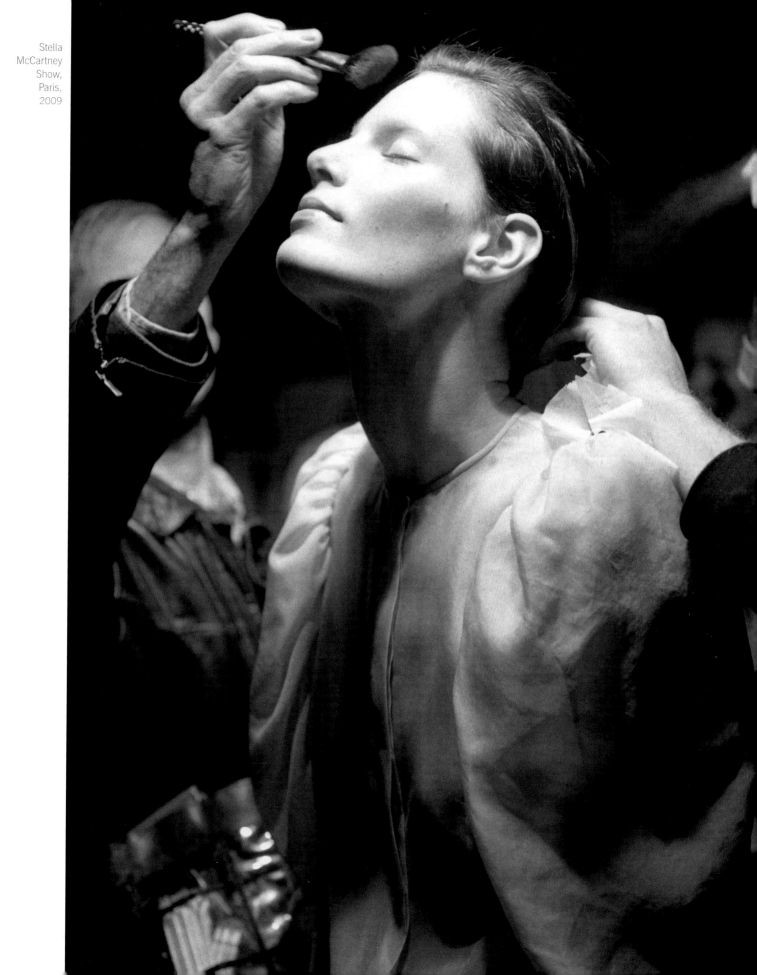

Stella
McCartney
Show,
Paris,
2009

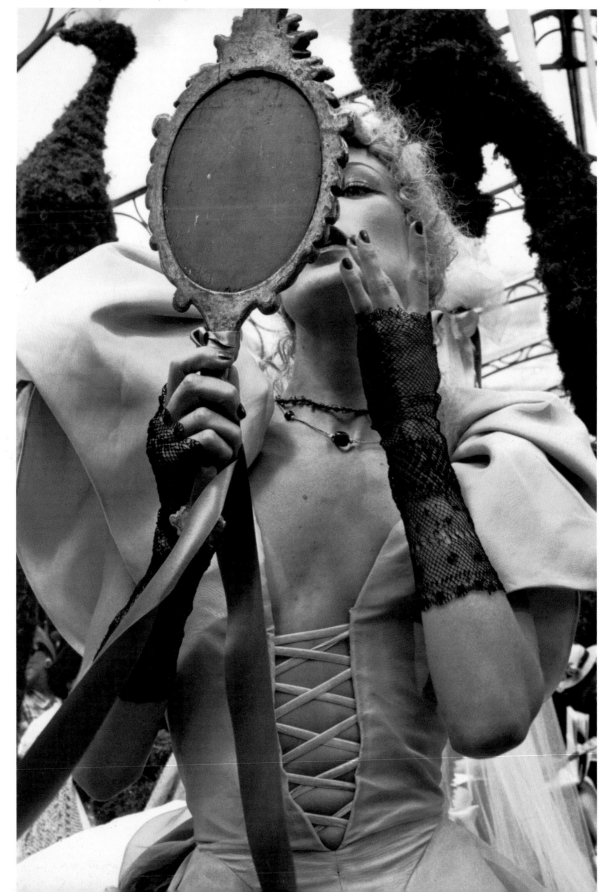

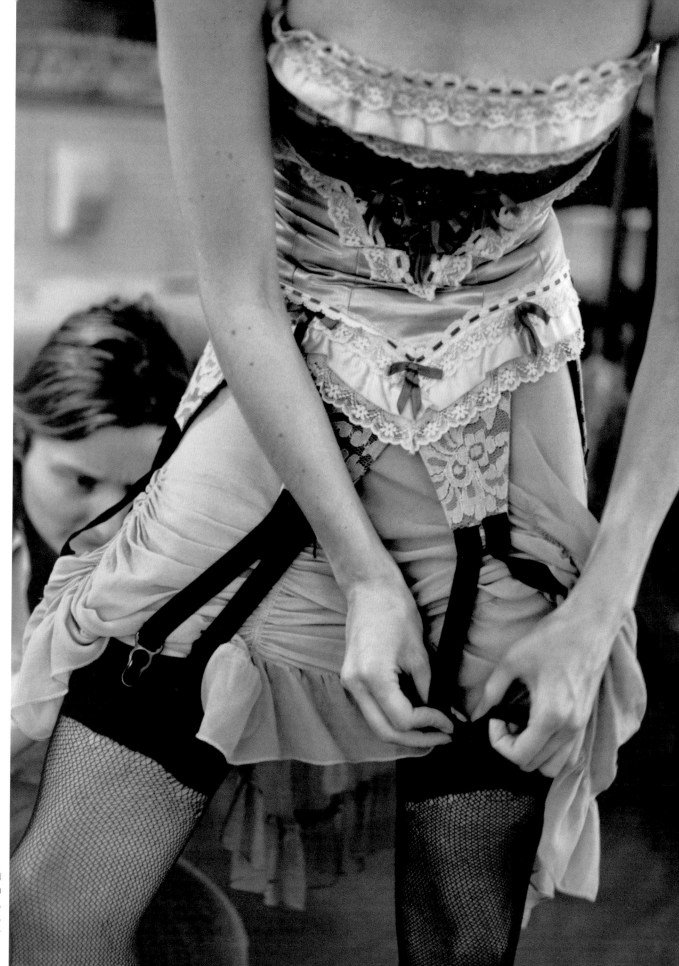

Royal
Opera
House,
London,
2004

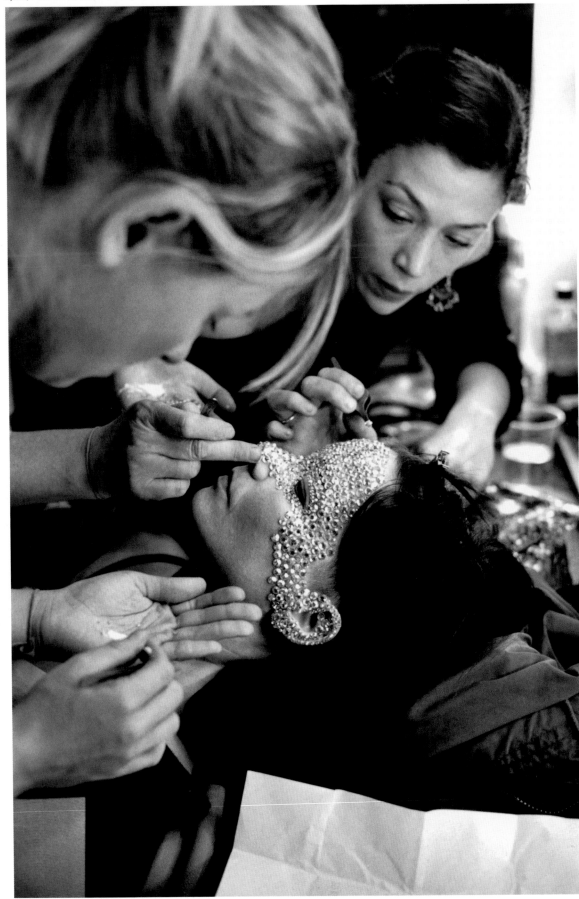

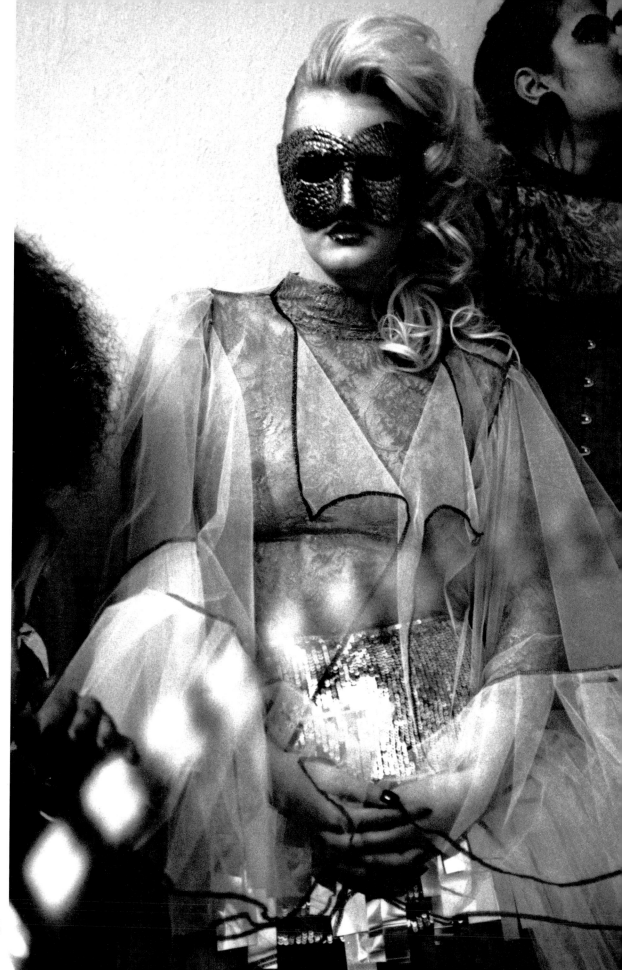

House of Blueeyes,
London, 2009

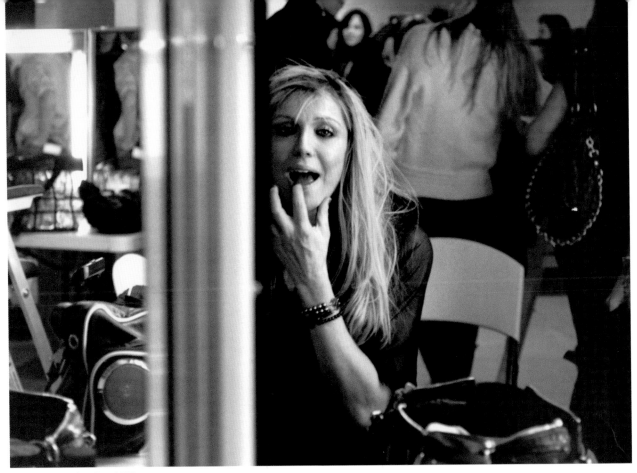

Courtney Love, London, 2008

London, 2009

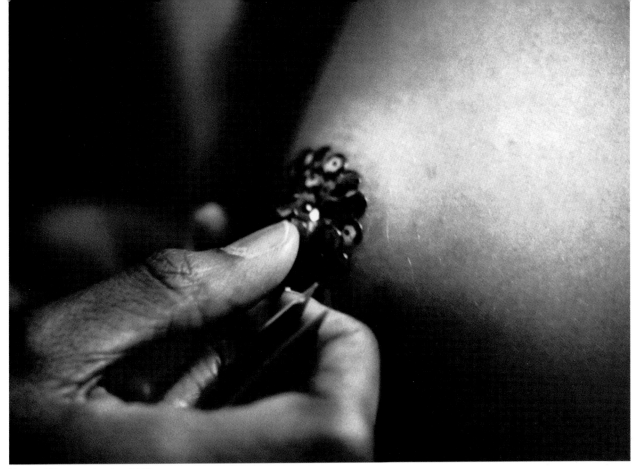

House of Blueeyes, London, 2008

Royal Festival Hall, London, 2003

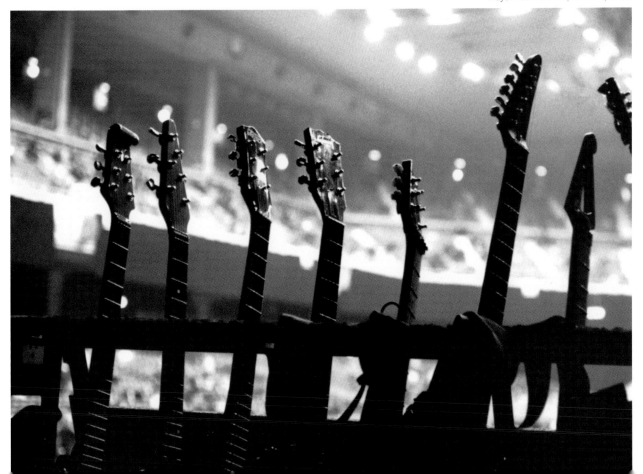

Royal Festival Hall, London, 2003

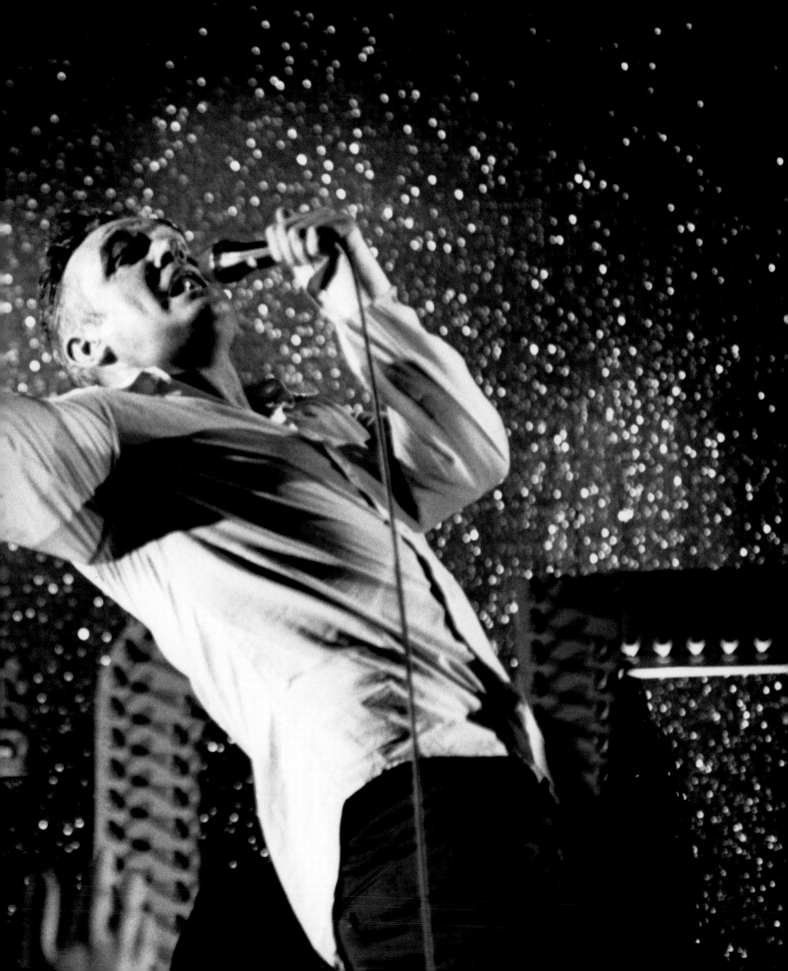

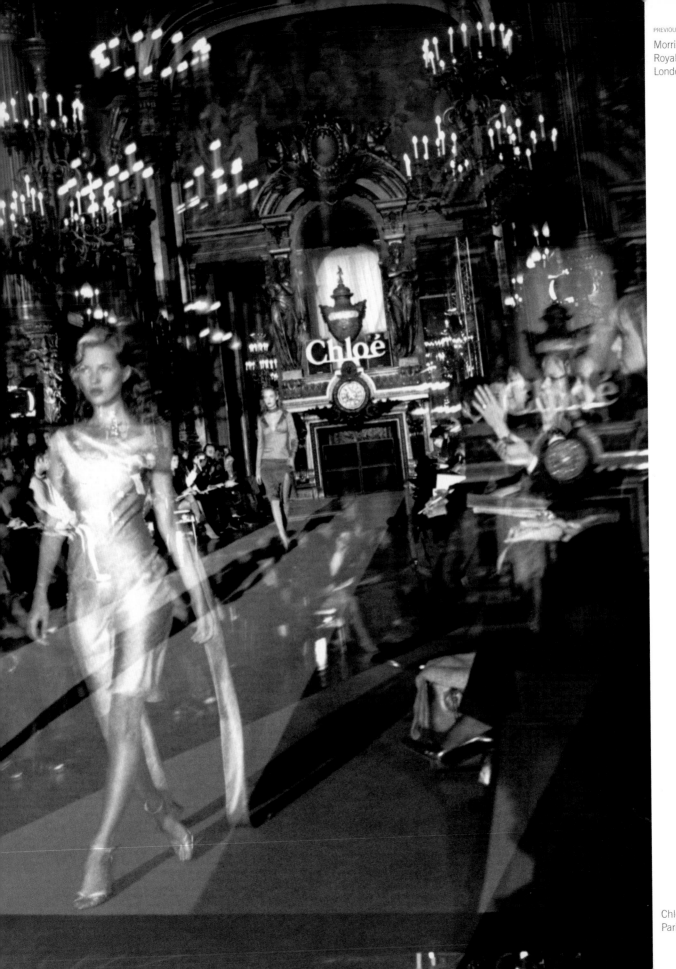

Chloé Show,
Paris, 1997

Fashion Rocks,
London, 2003

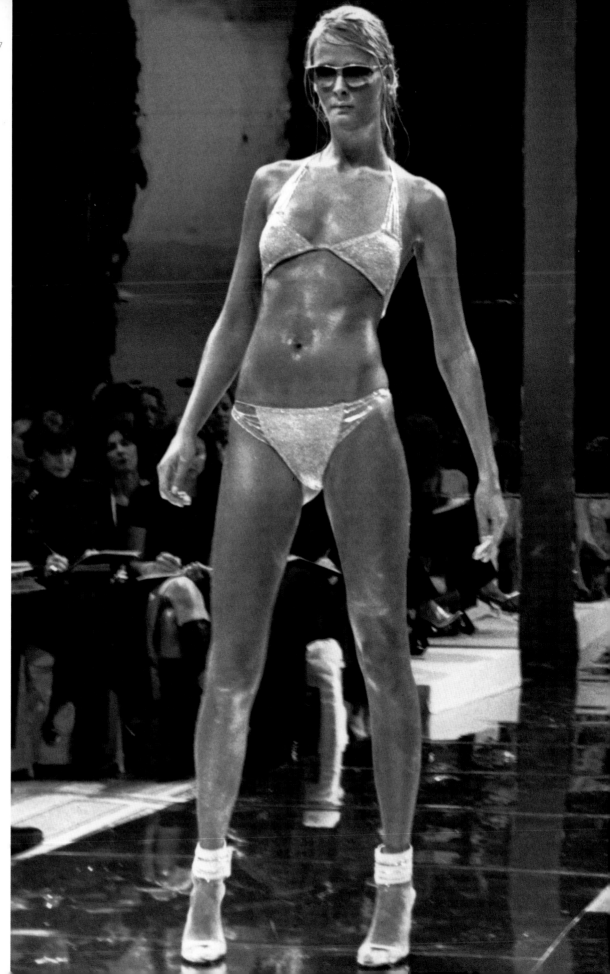

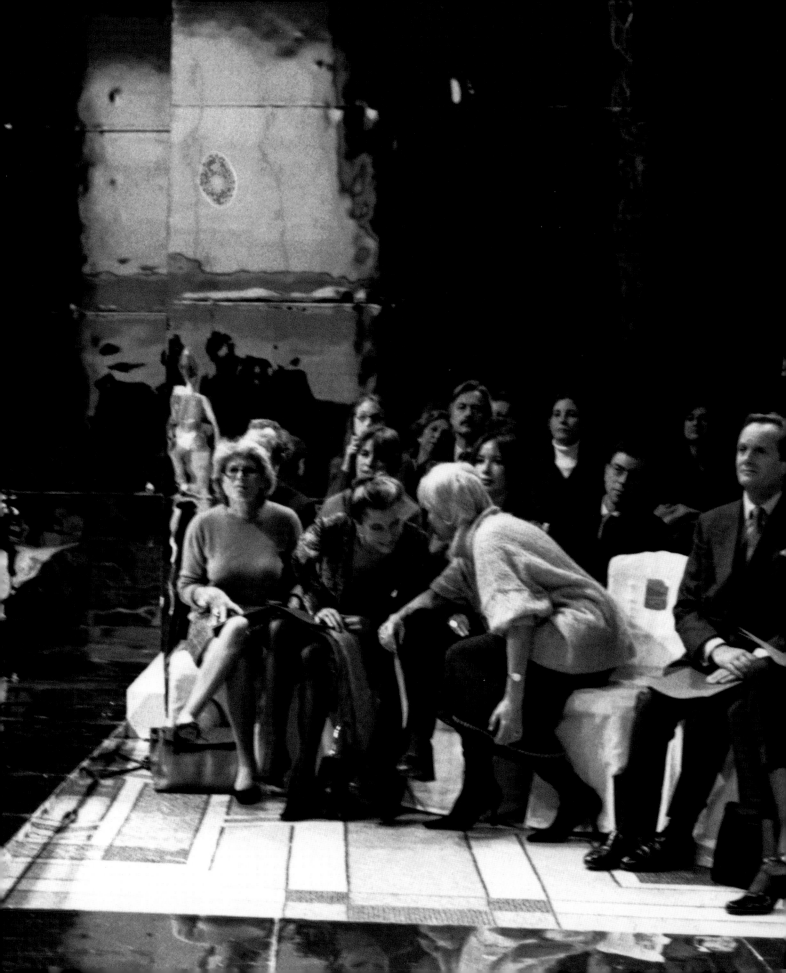

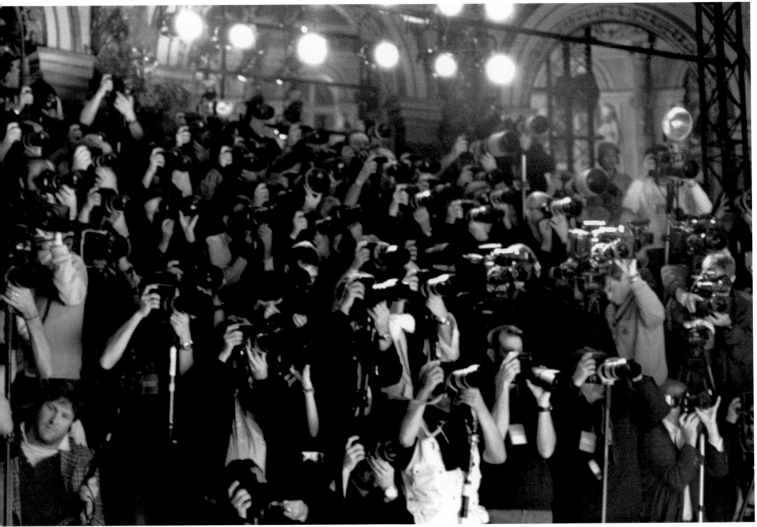

Stella McCartney Show, Paris, 2006

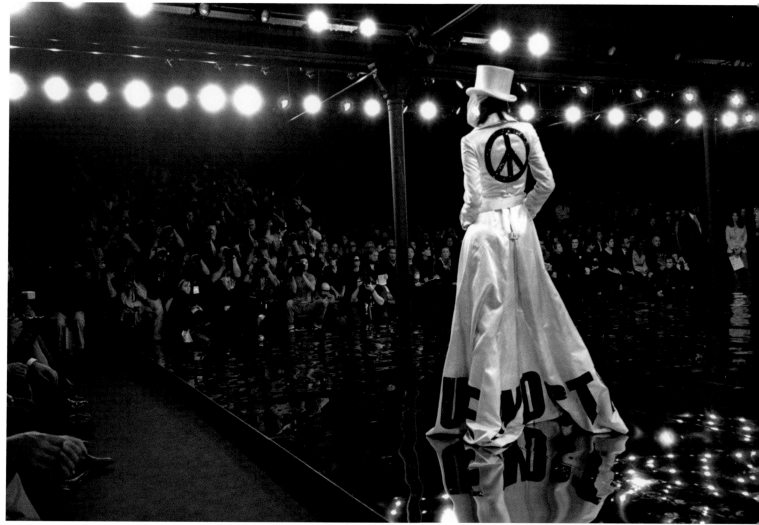

Stella McCartney Show, Paris, 2001

Björk, Royal Albert Hall, London, 2003

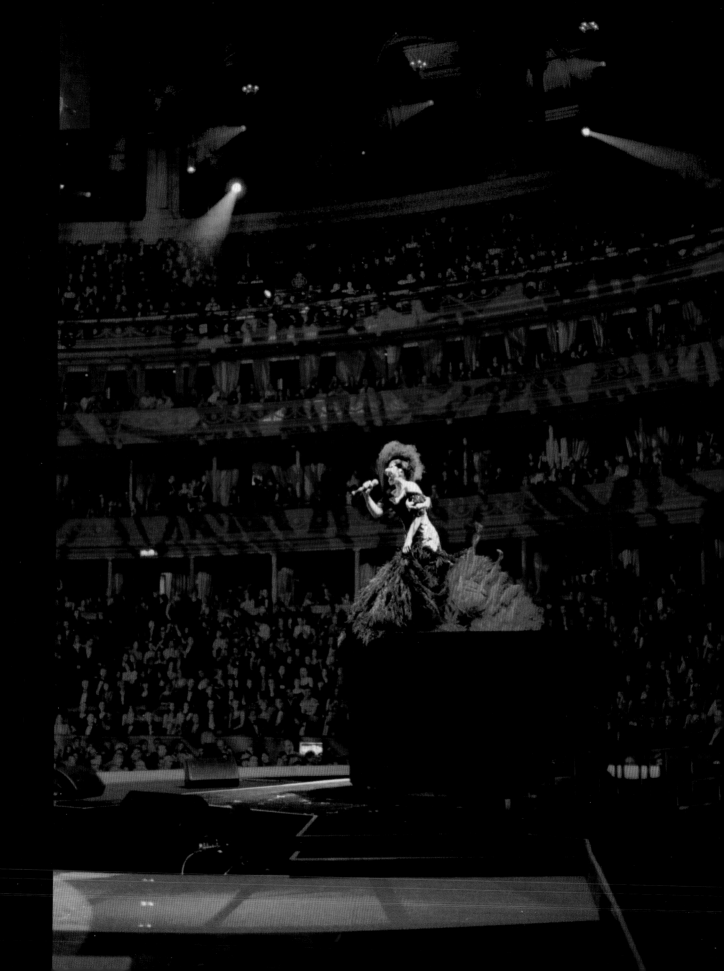

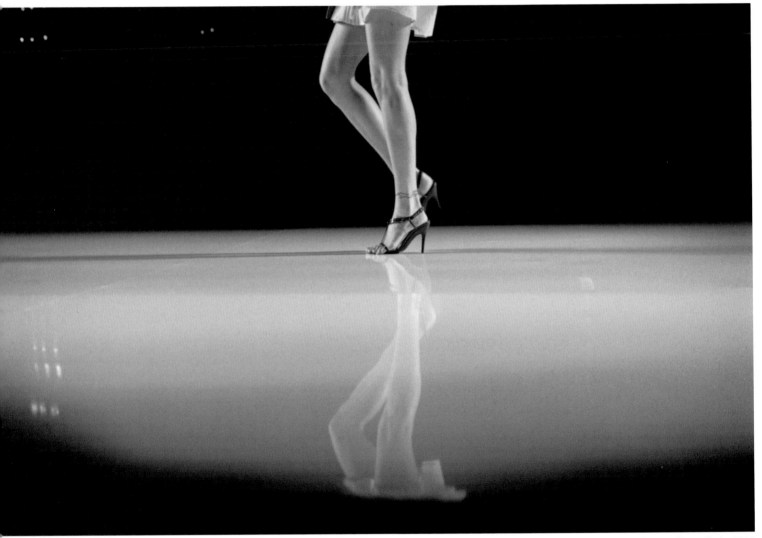

Stella McCartney Show, Paris, 2006

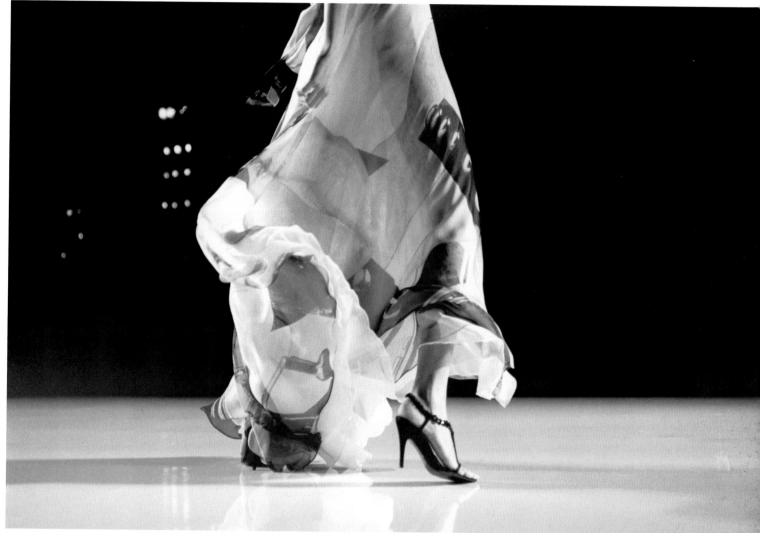

Stella McCartney Show, Paris, 2006

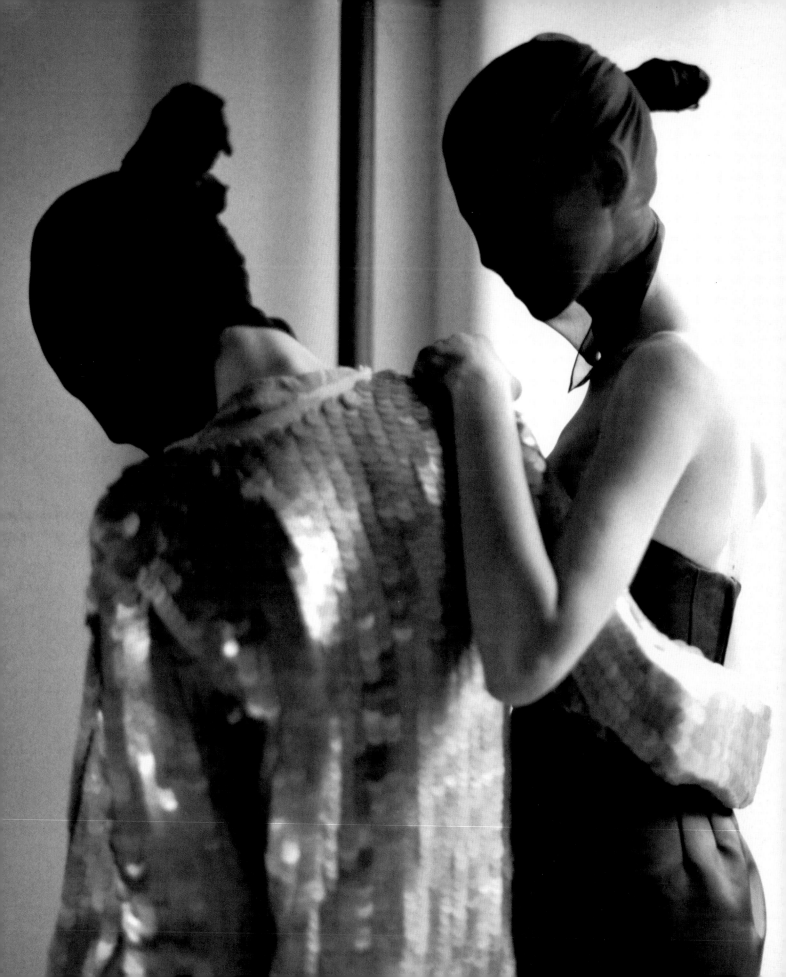

Giles Deacon Show, London, 2008

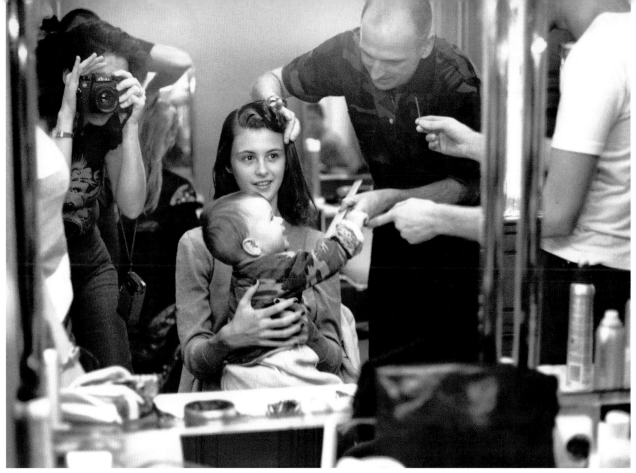

Chloé Show, Paris, 1997

Live 8, Hyde Park, London, 2005

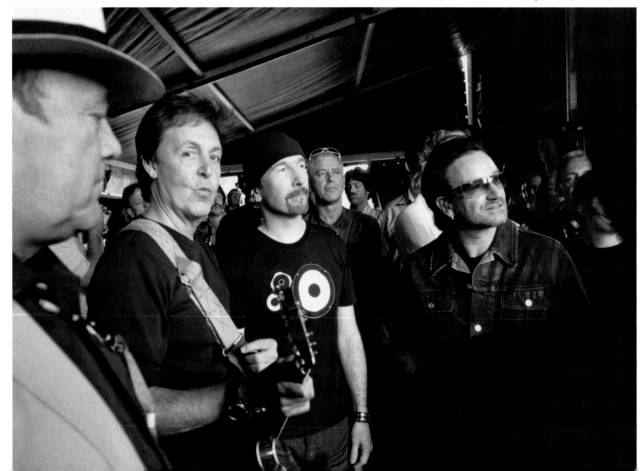

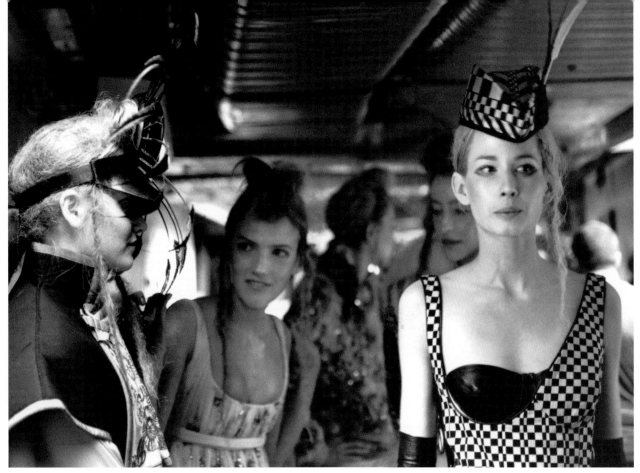

Fashion Rocks, London 2003

Stella McCartney Show, Paris, 2001

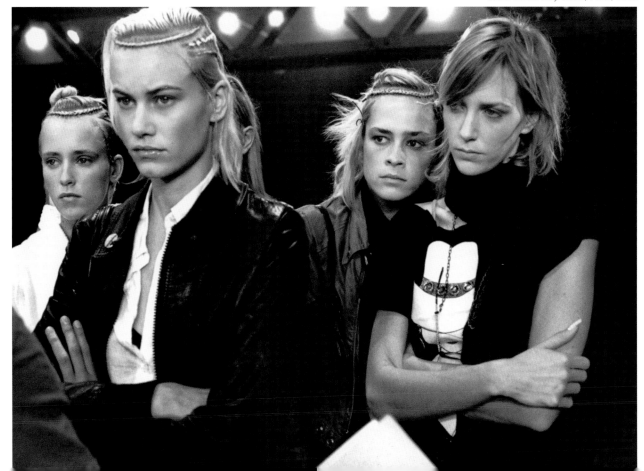

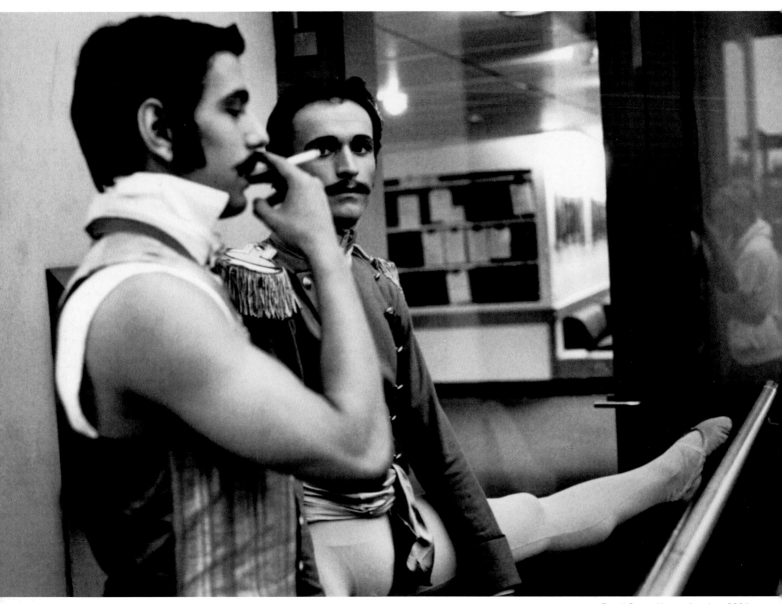

Royal Opera House, London, 2004

OPPOSITE Sian Murphy, Royal Opera House, London 2004

FOLLOWING PAGES Chloé Show, Paris, 2000

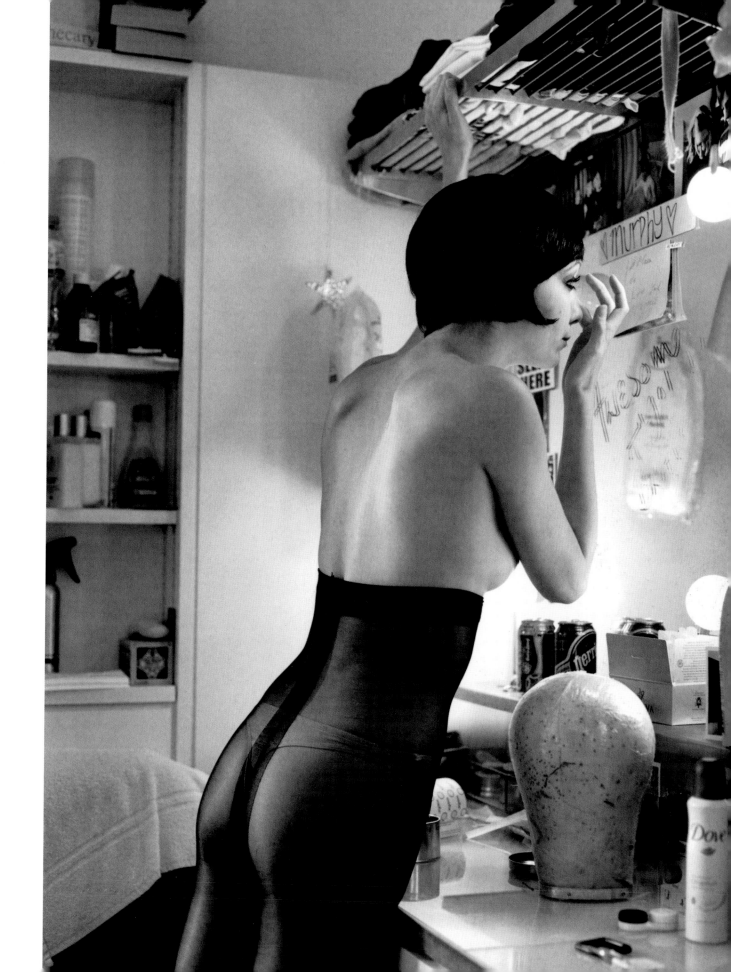

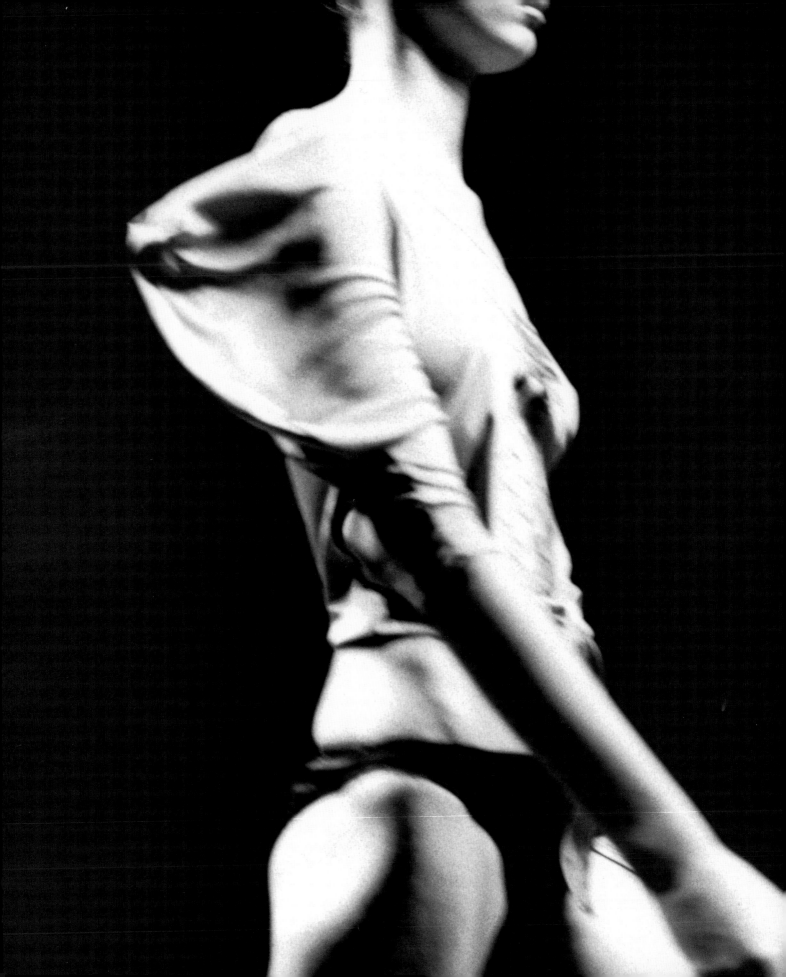

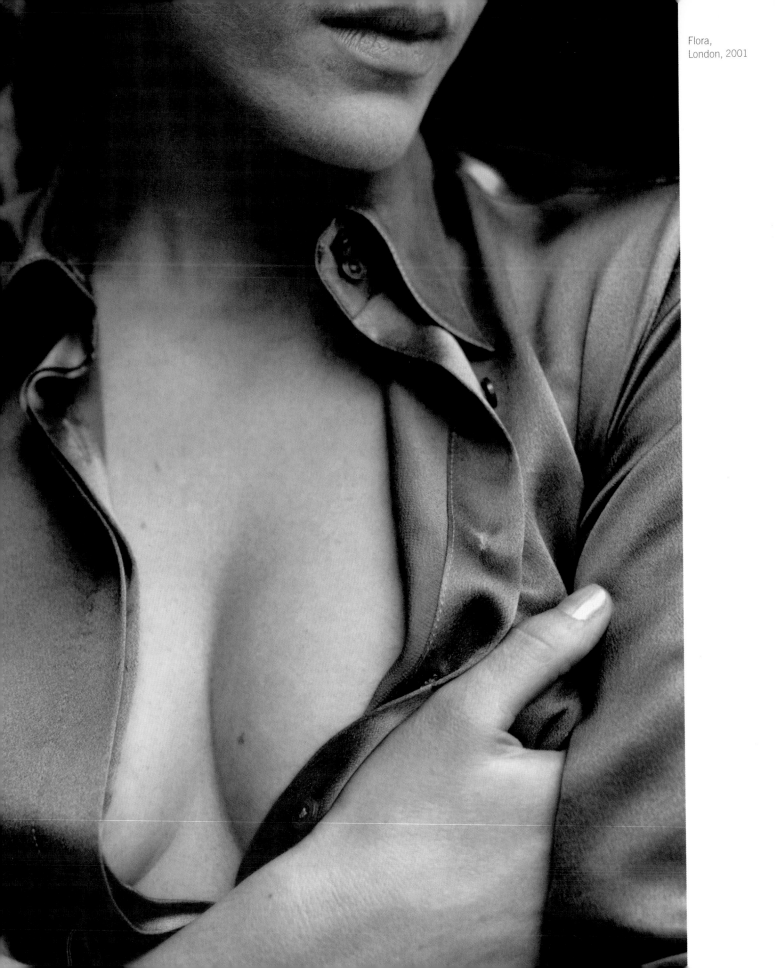

Flora,
London, 2001

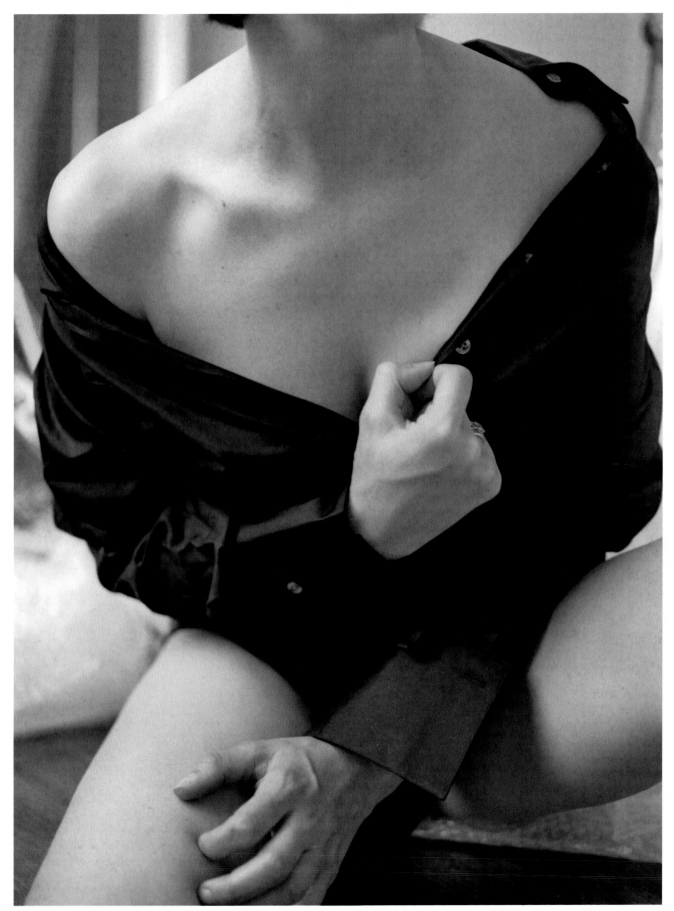

Sam, London, 2001

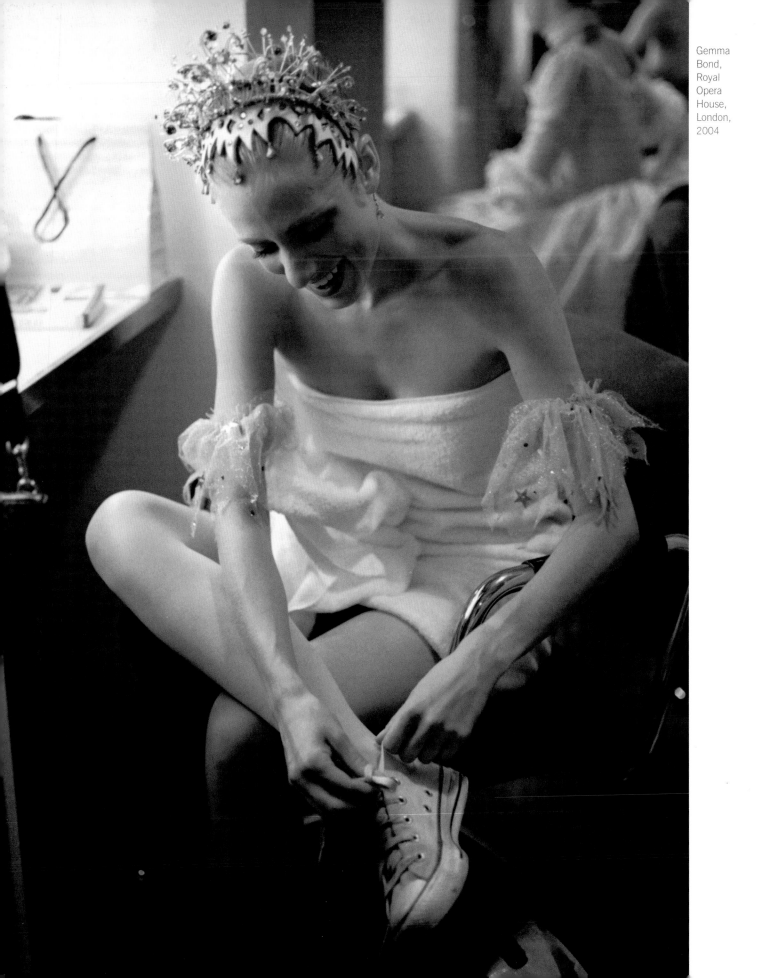

Gemma
Bond,
Royal
Opera
House,
London,
2004

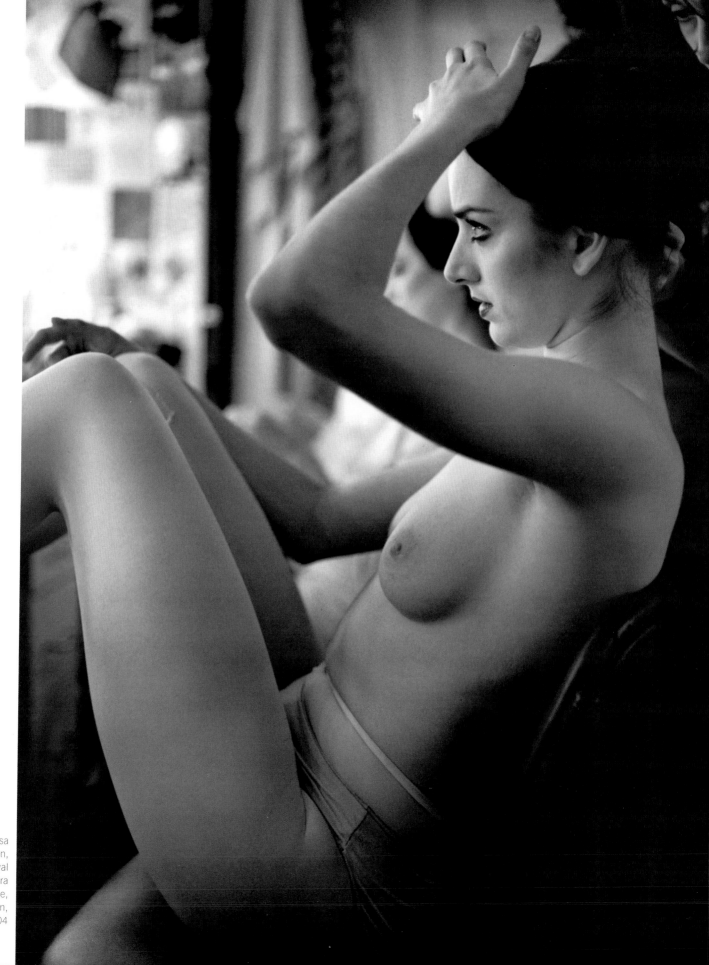

Vanessa
Fenton,
Royal
Opera
House,
London,
2004

Phoenix Festival, Stratford-upon-Avon, 1996

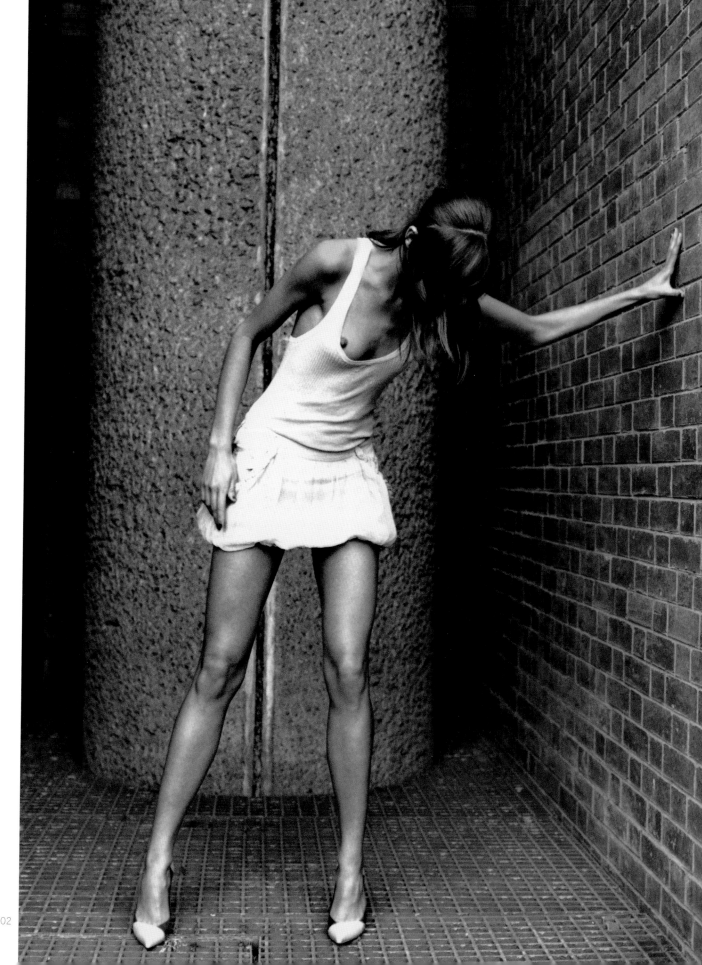

London, 2002

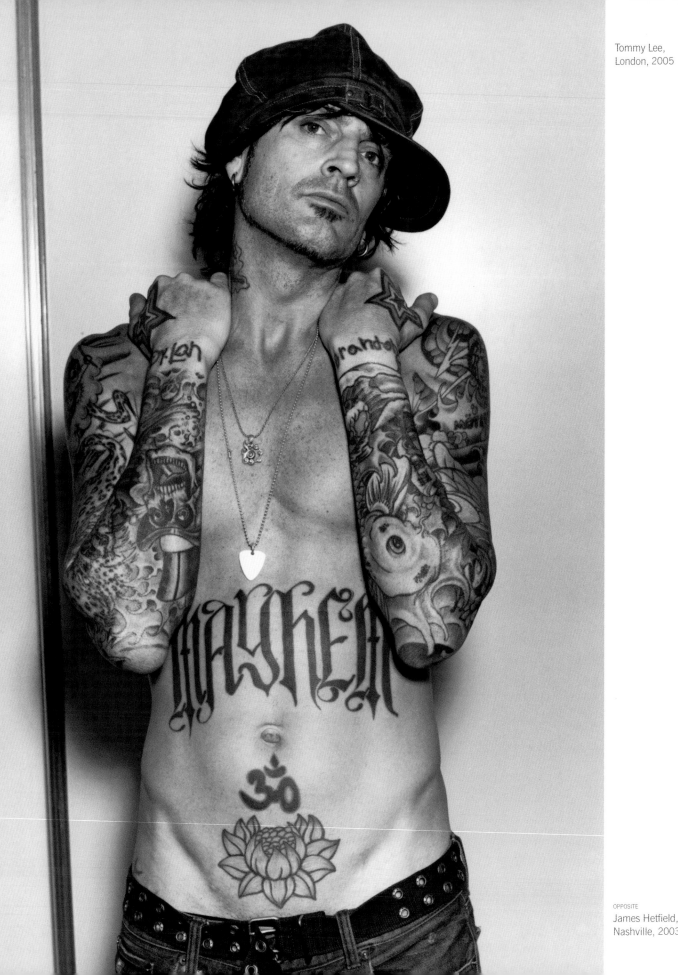

Tommy Lee,
London, 2005

OPPOSITE
James Hetfield,
Nashville, 2003

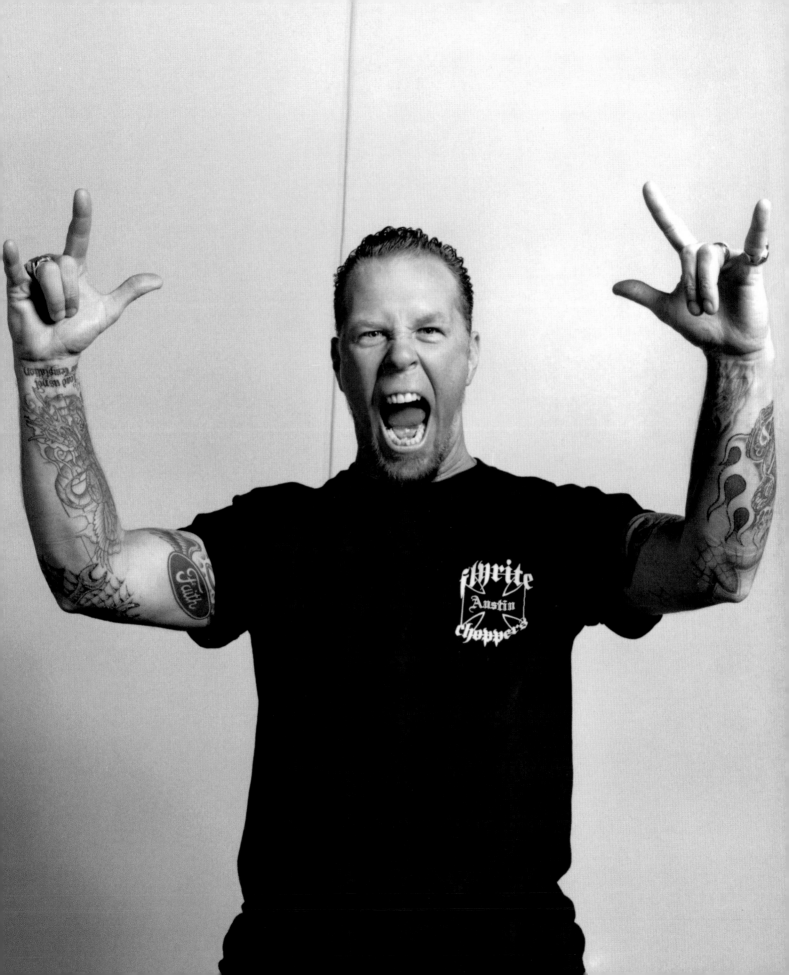

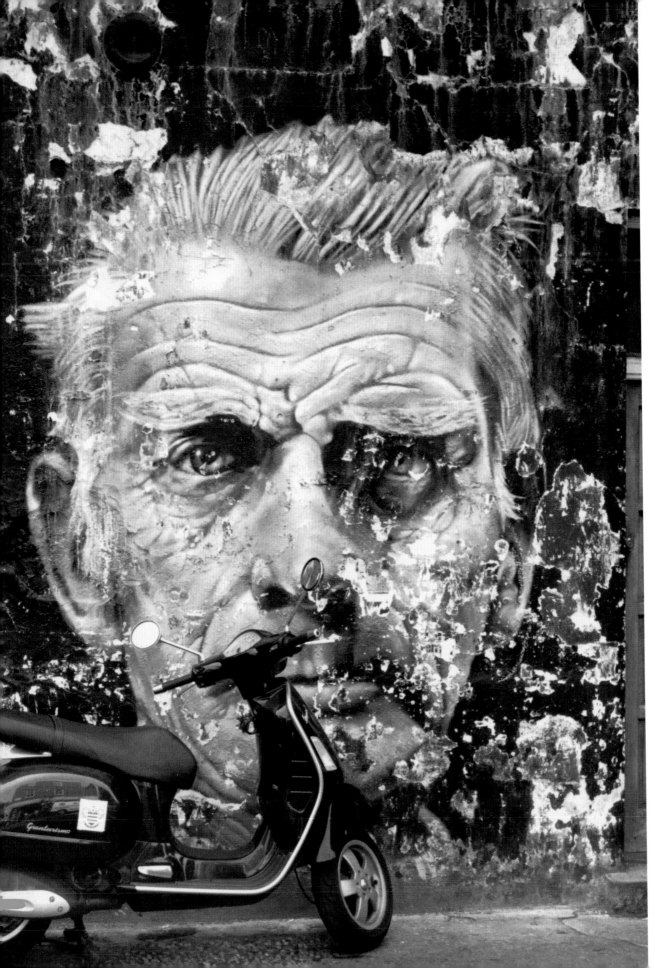

Samuel Beckett,
London, 2008

Michael Stipe,
London, 2003

"

This photo was taken
during two afternoons
I spent with Joni
Mitchell at Lyndhurst
Hall. It was amazing
to see her at work,
reworking some of her
best songs. Dignified.
Such elegance. I was
captivated by her and
could have spent many
more days watching
her. Her image is just
so strong, just as
you'd expect.

Joni Mitchell, London, 2001

FOLLOWING PAGES
Debbie Harry and Chris Stein, New York City, 2001

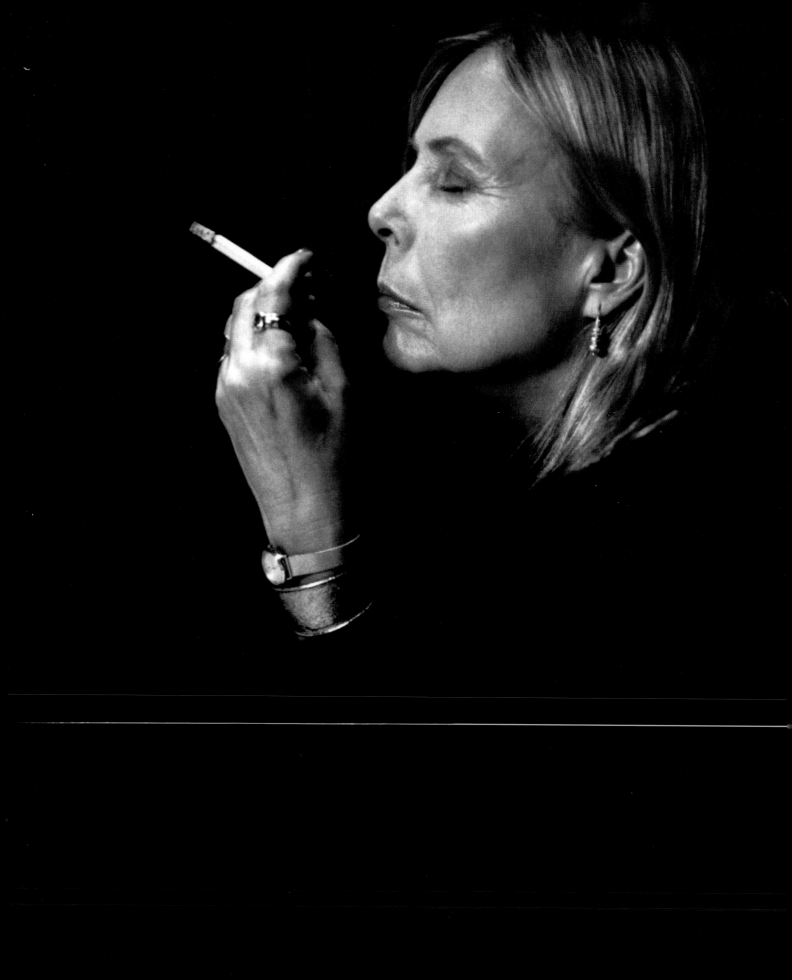

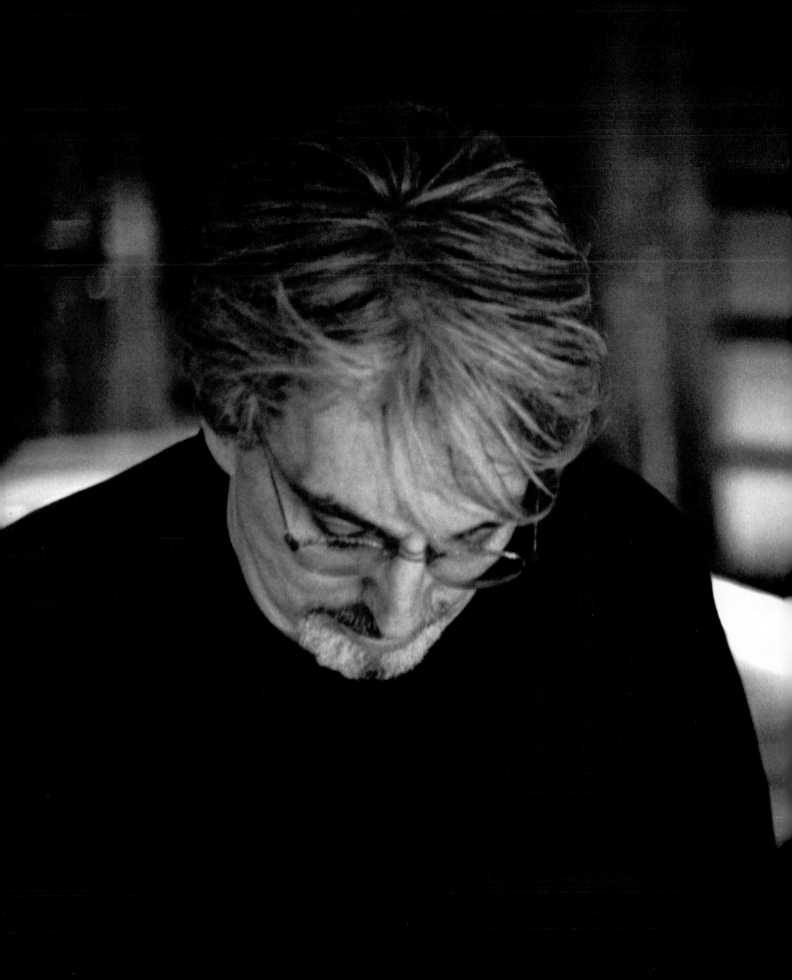

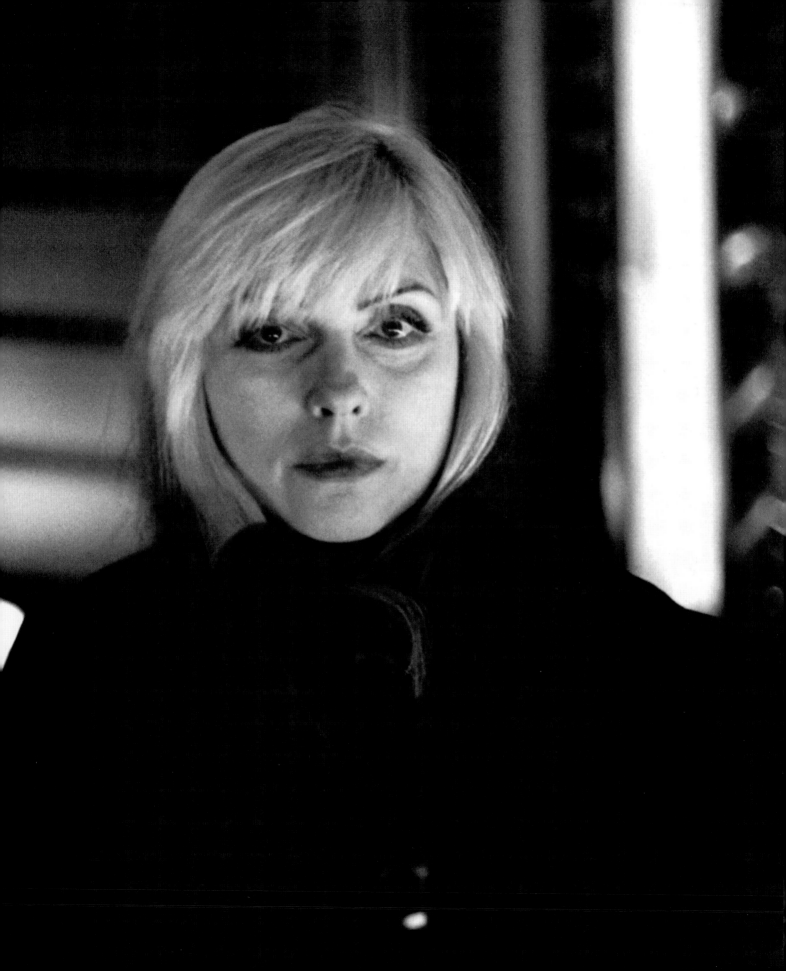

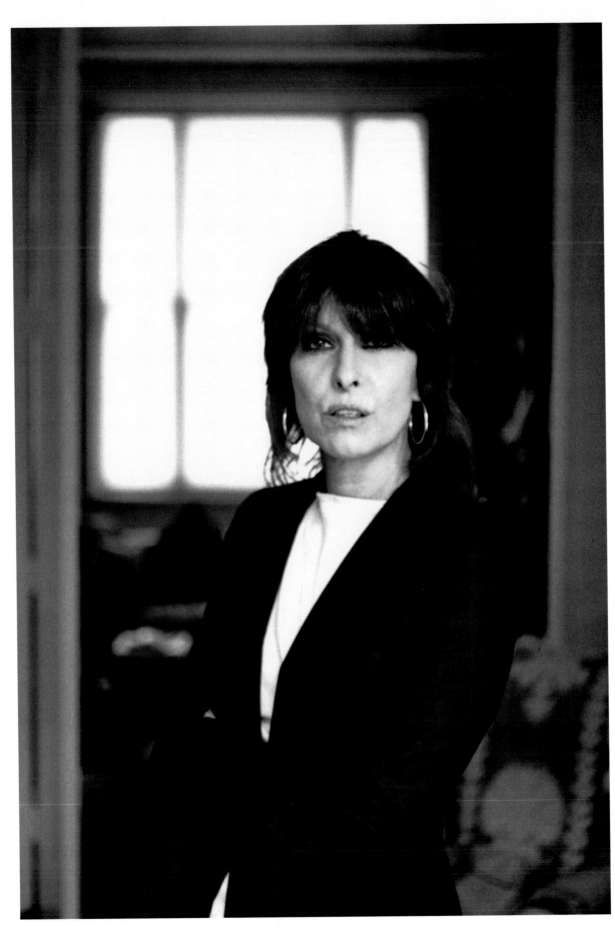

Chrissie Hynde,
London, 2003

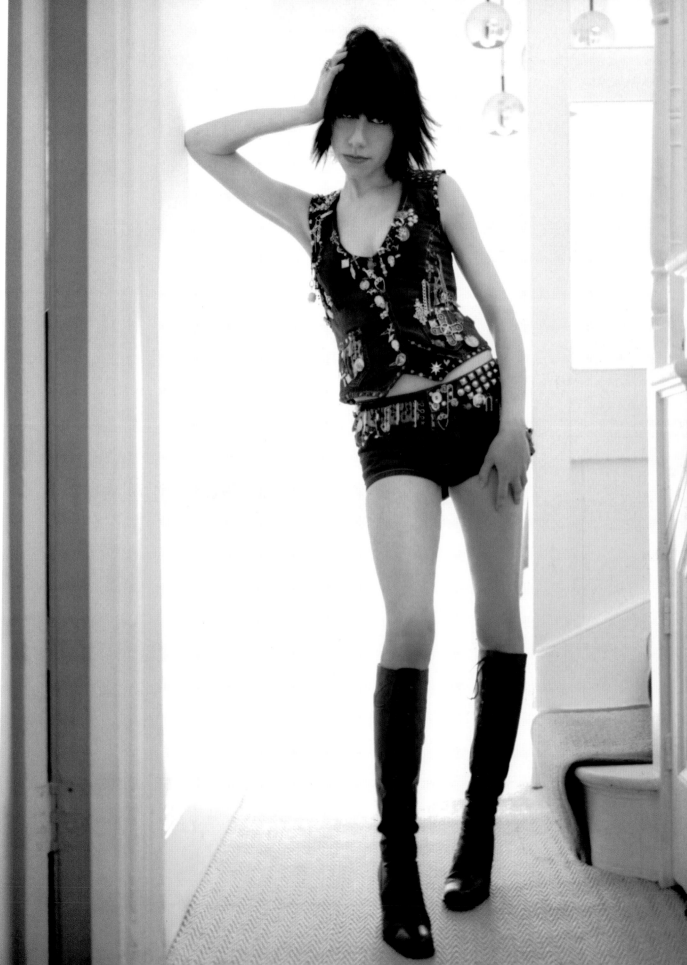

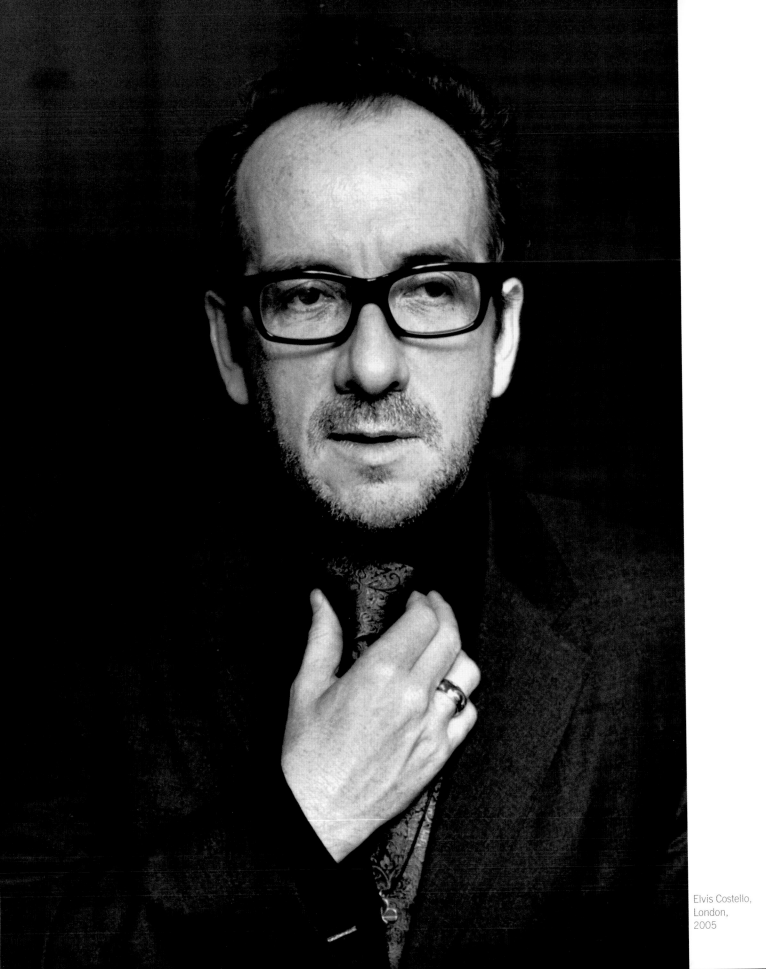

Elvis Costello,
London,
2005

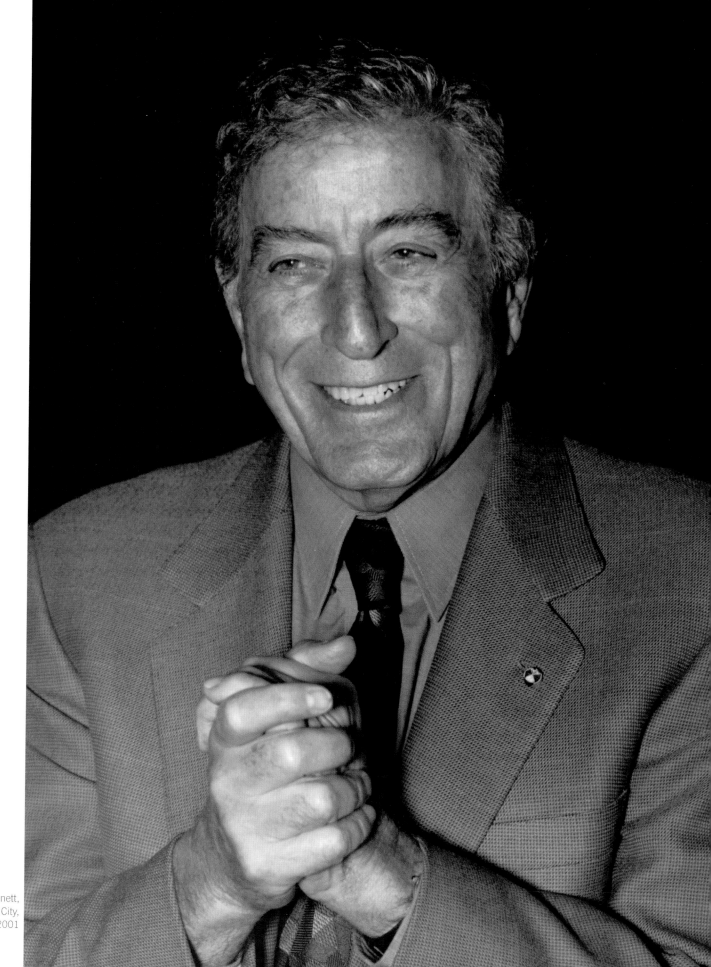

Tony Bennett,
New York City,
2001

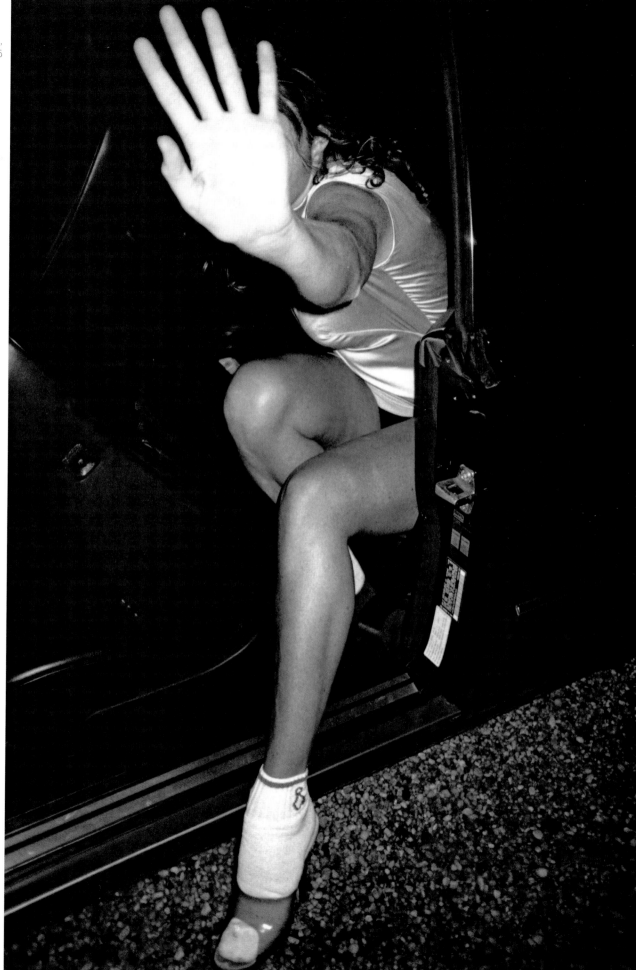

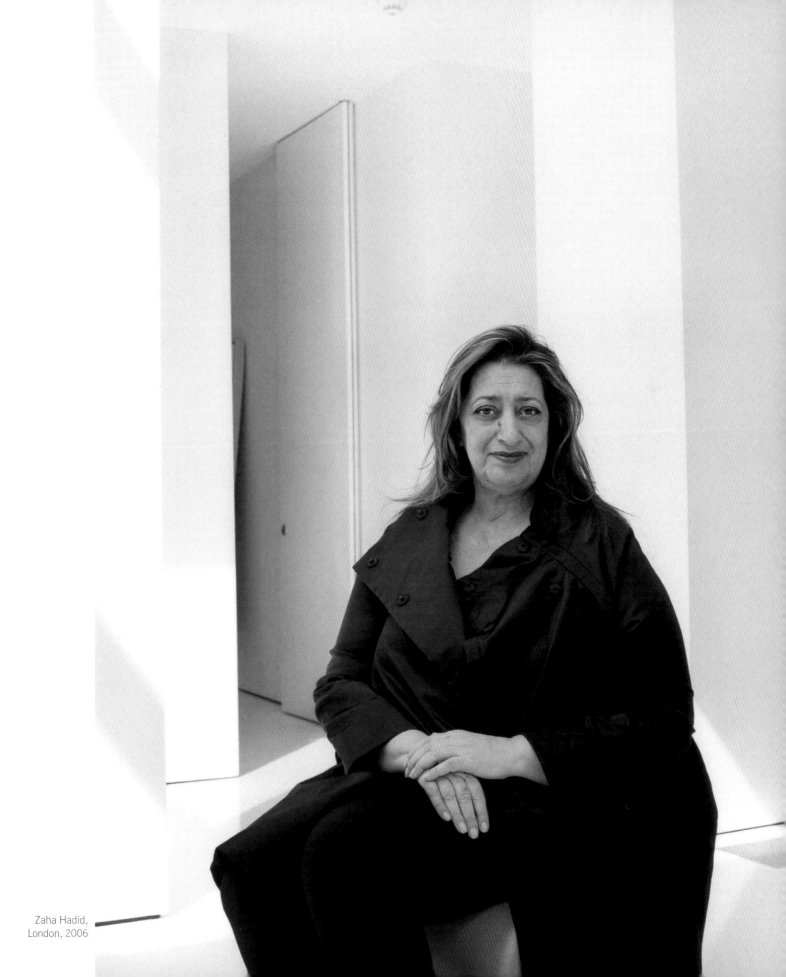

Zaha Hadid,
London, 2006

This was my first encounter with Tracey. She already had a great affinity with Frida Kahlo, which you can see in her complete connection with the artist and character.

"

Tracey Emin as Frida Kahlo, London, 2000

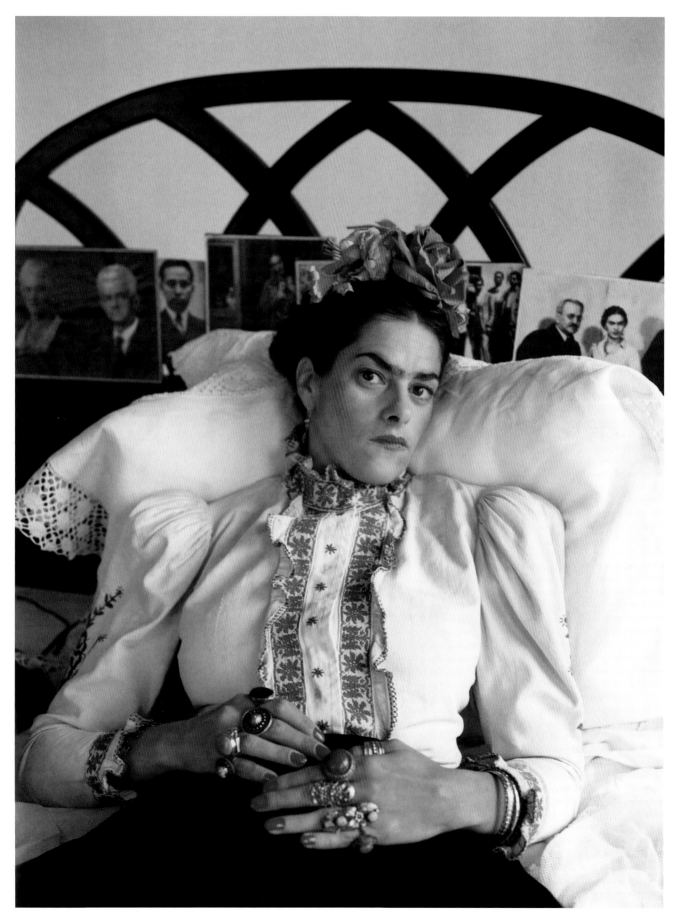

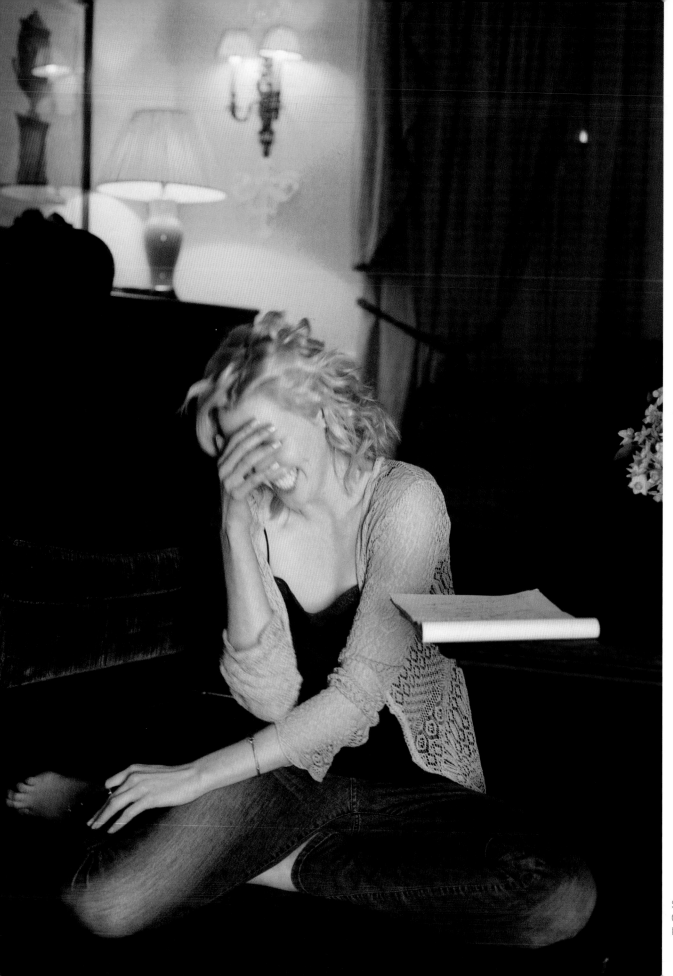

Sophie Dahl,
Claridges,
London, 2003

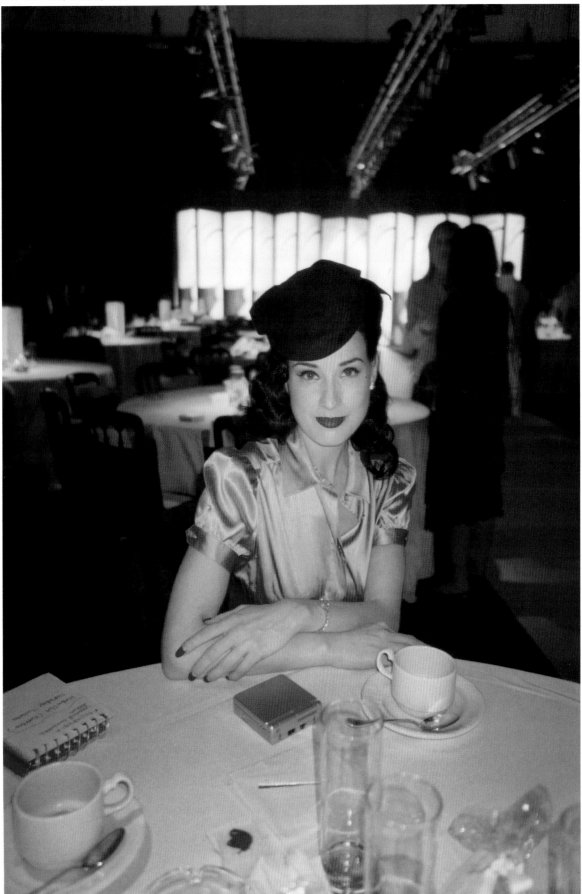

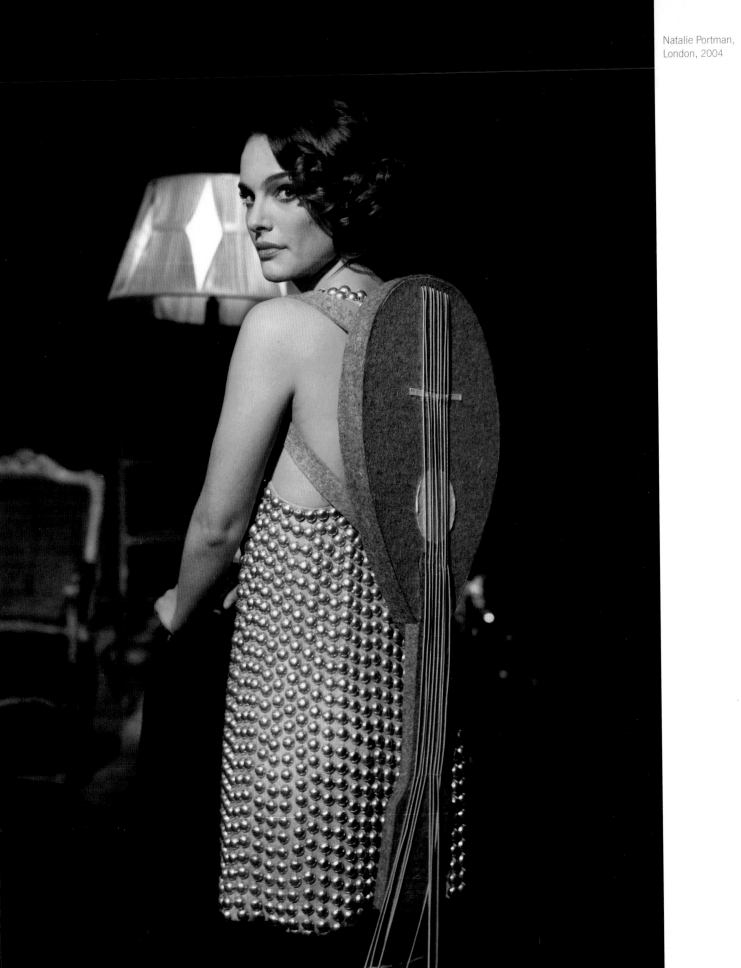

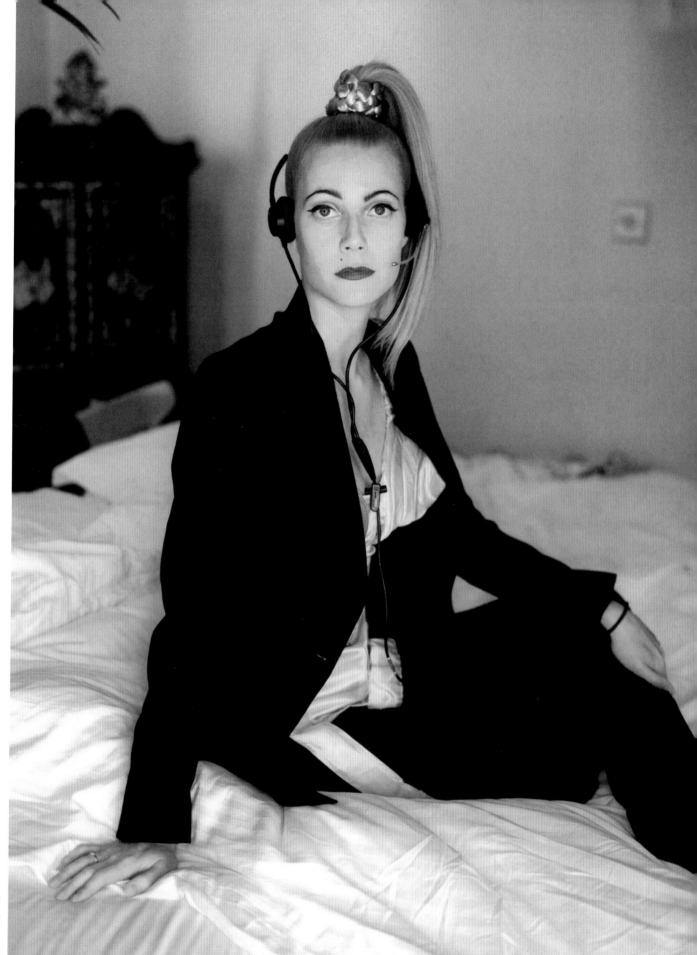

Gwyneth Paltrow
as Madonna,
London, 2004

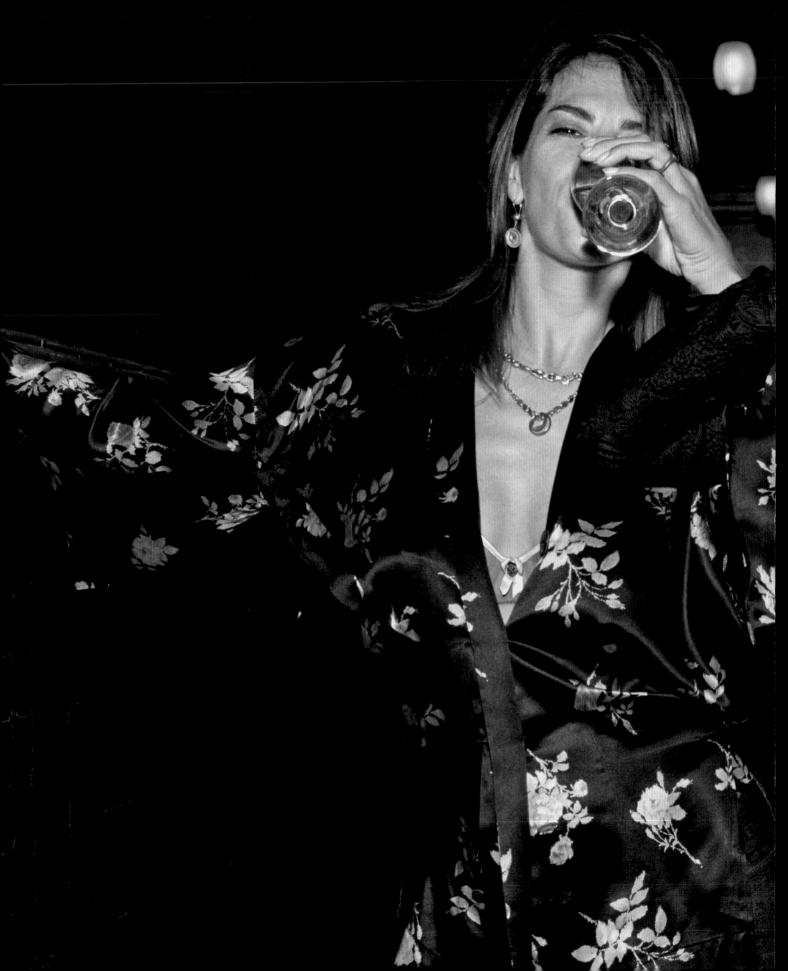

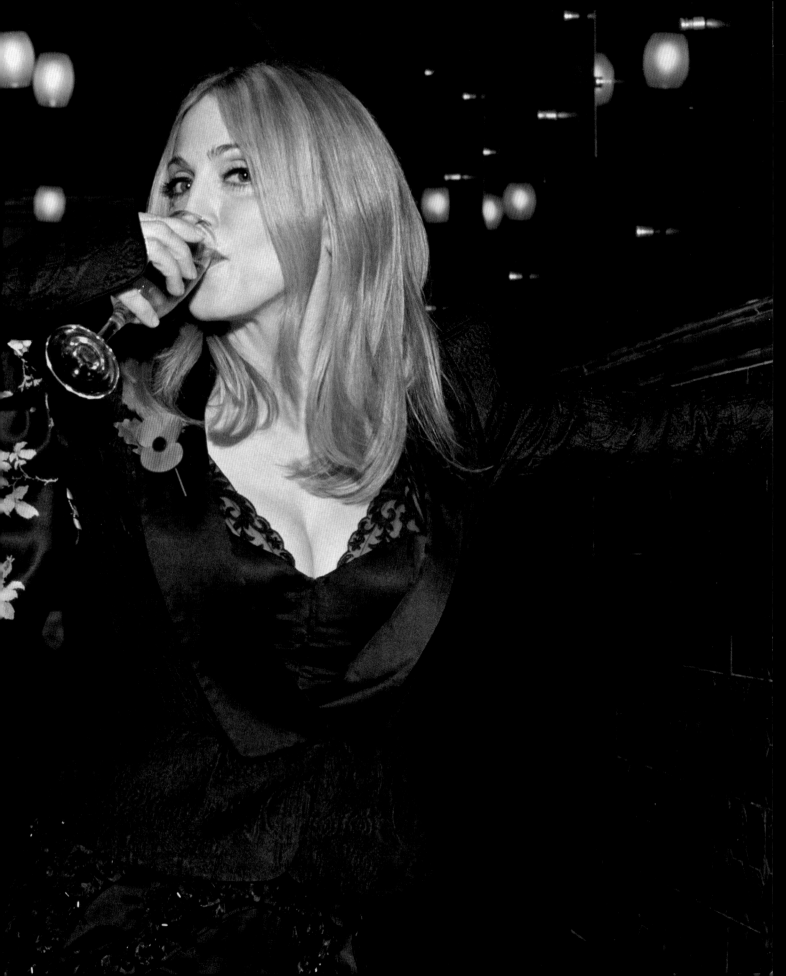

PREVIOUS PAGES
Tracey Emin and Madonna, Rock and Roll Hall of Fame, London, 2004

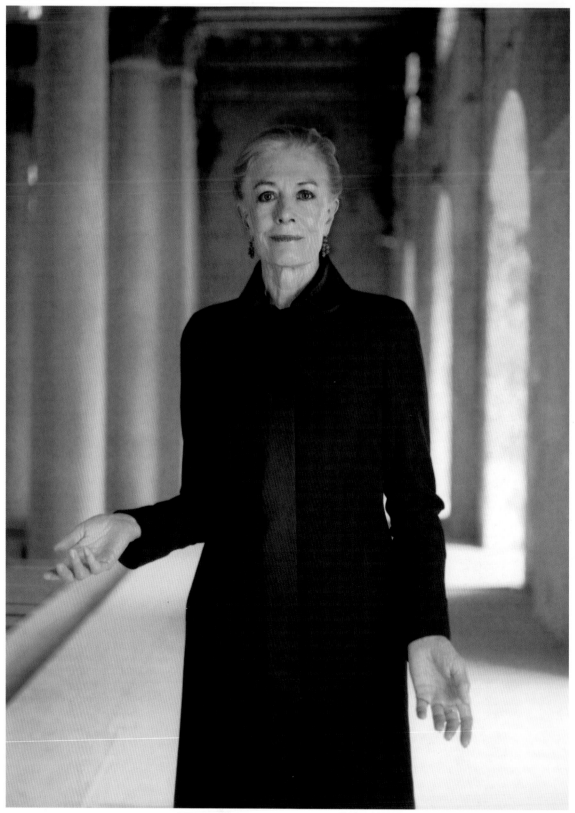

Vanessa Redgrave, Christ Church, Spitalfields, London, 2002

OPPOSITE Bella Freud, London, 2007

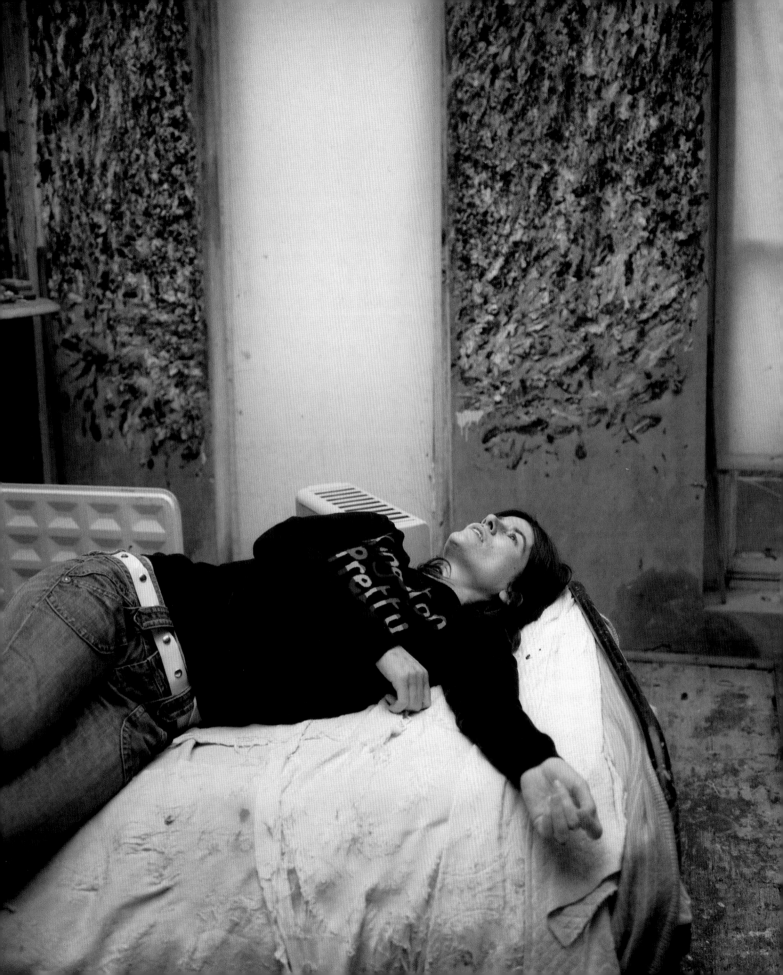

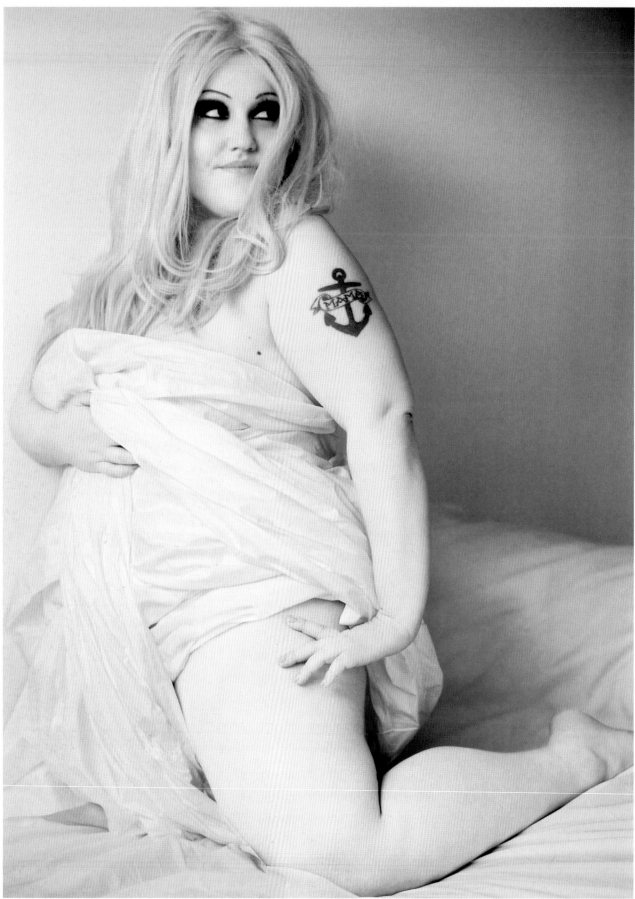

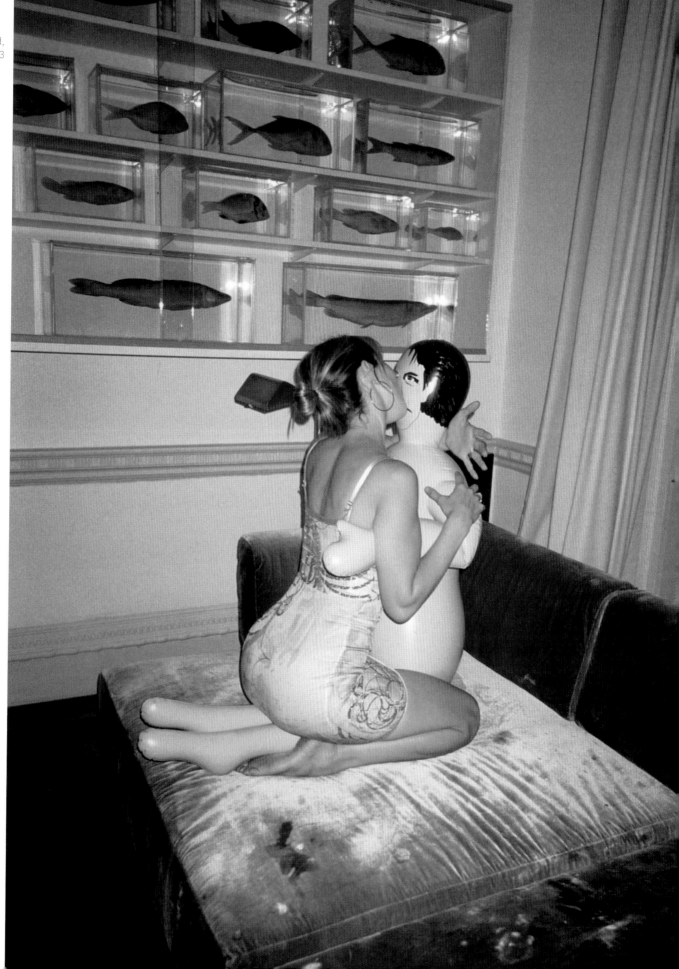

Sam Taylor-Wood,
London, 2003

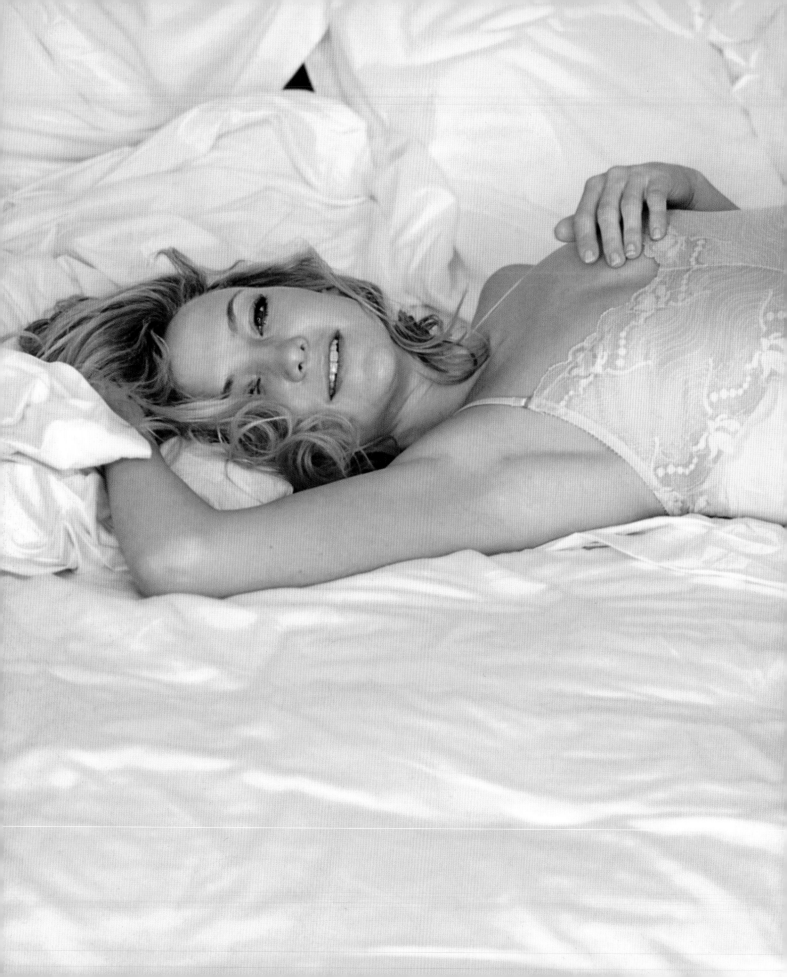

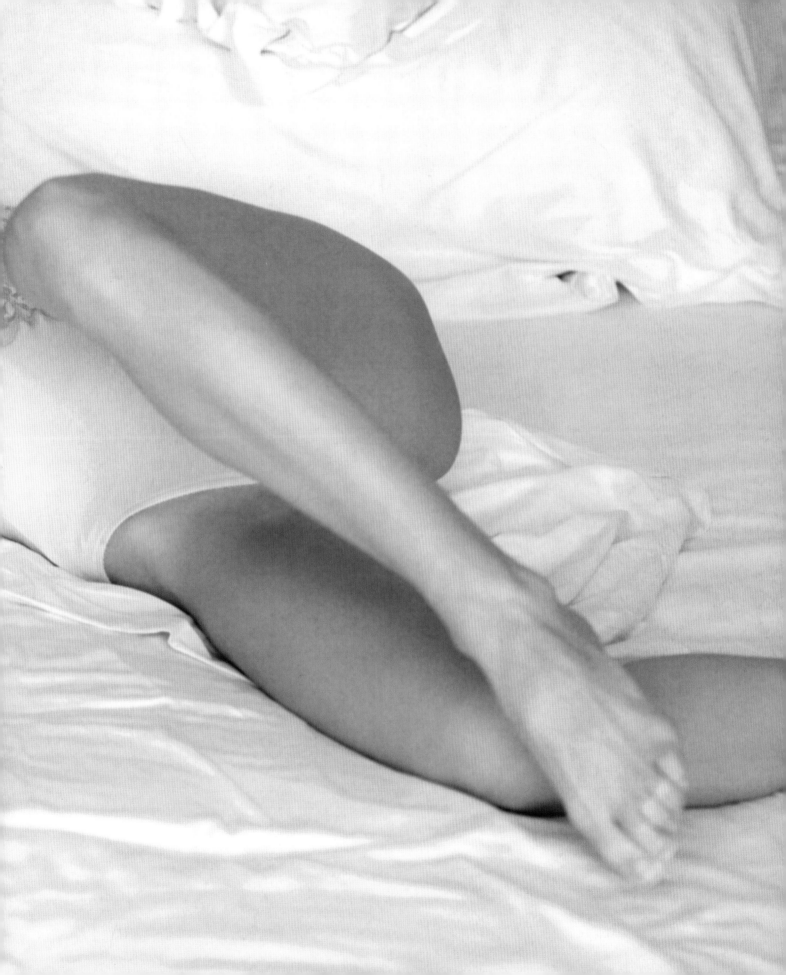

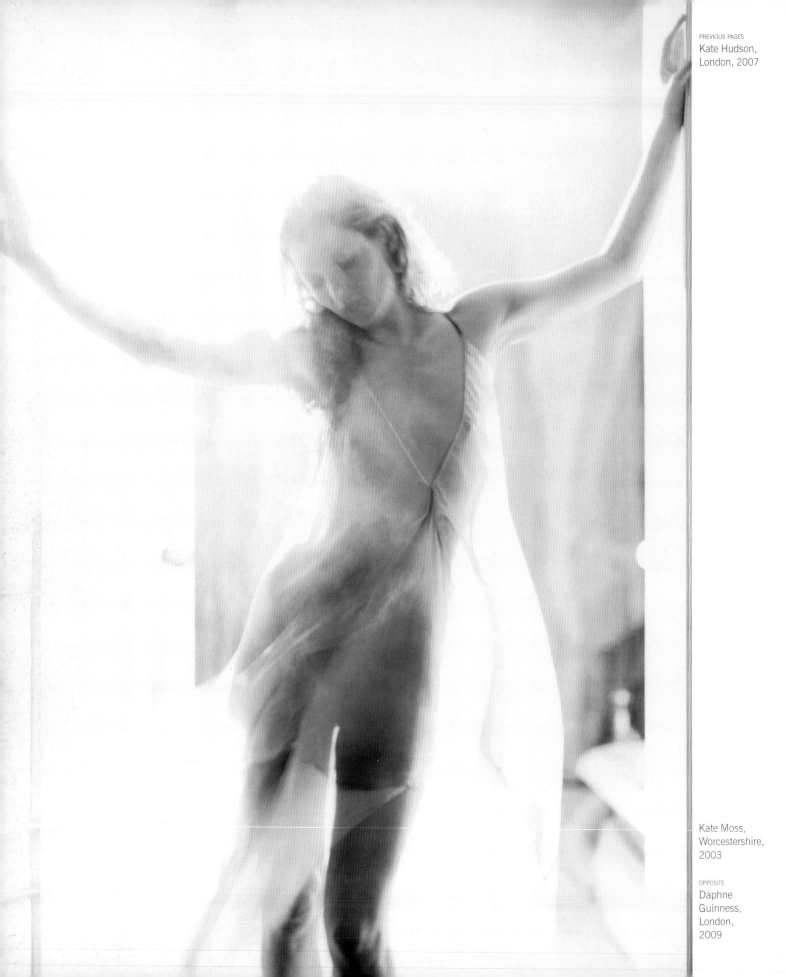

Kate Moss,
Worcestershire,
2003

OPPOSITE
Daphne
Guinness,
London,
2009

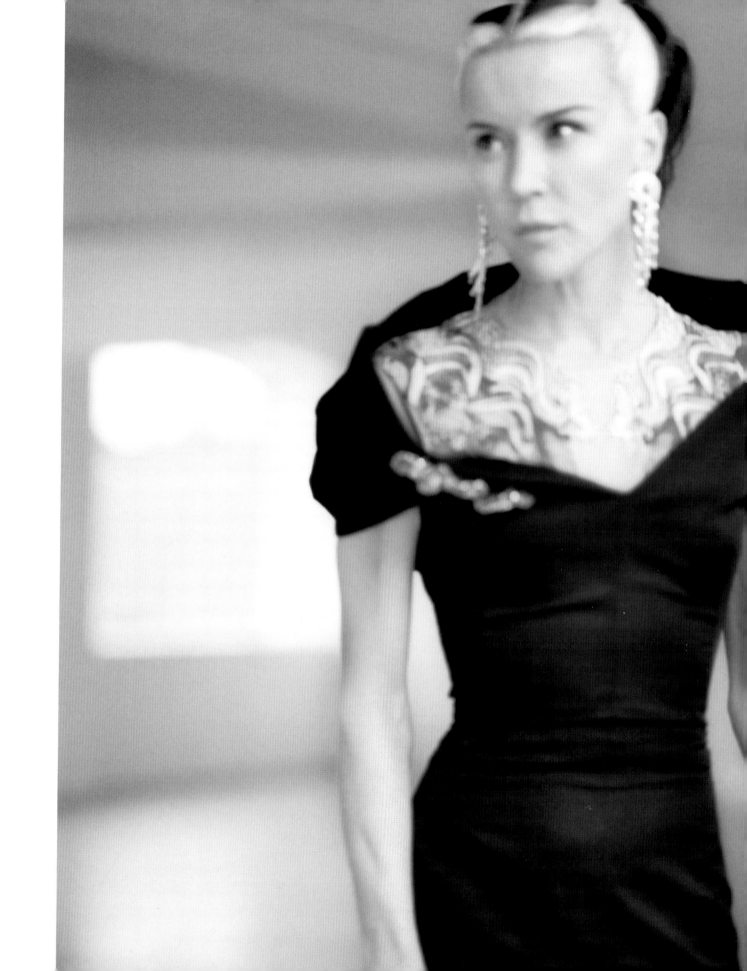

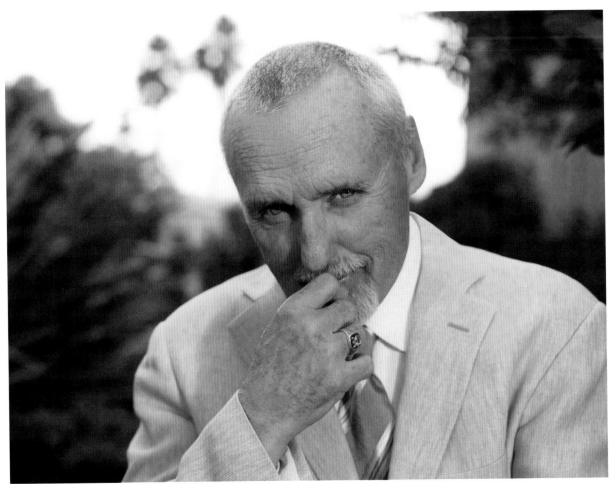

Dennis Hopper, Los Angeles, 2008

OPPOSITE Sam Morton, London, 2003

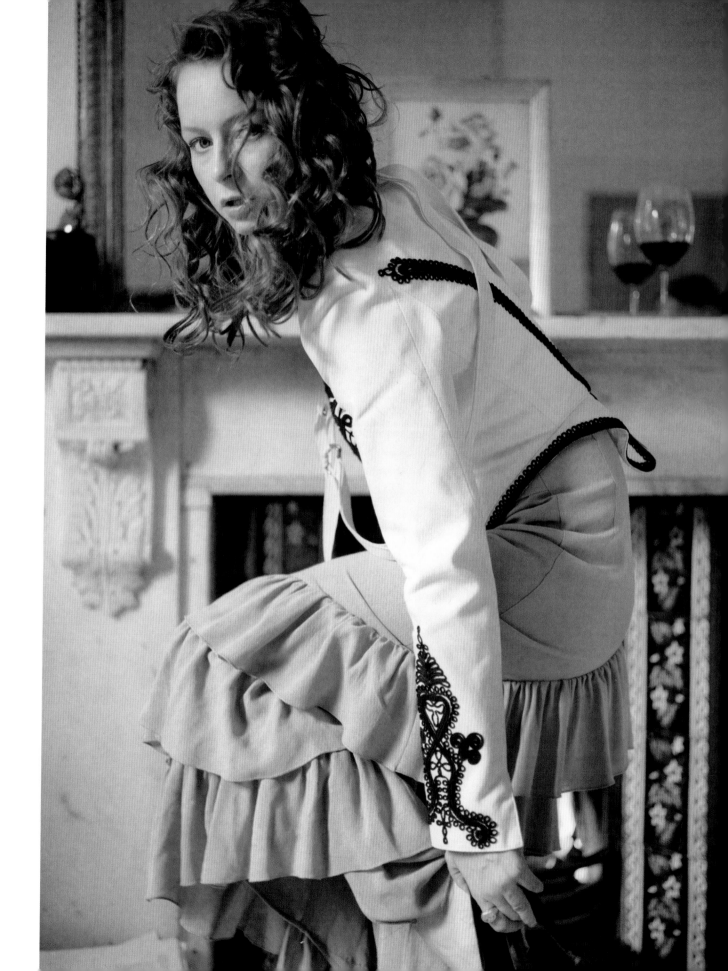

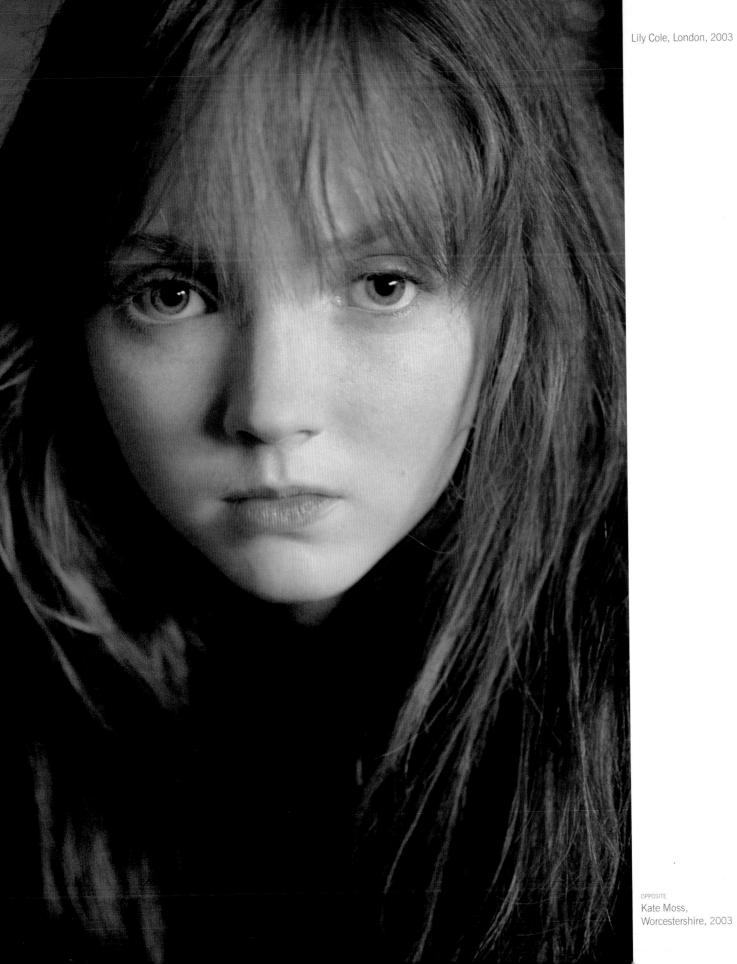

Lily Cole, London, 2003

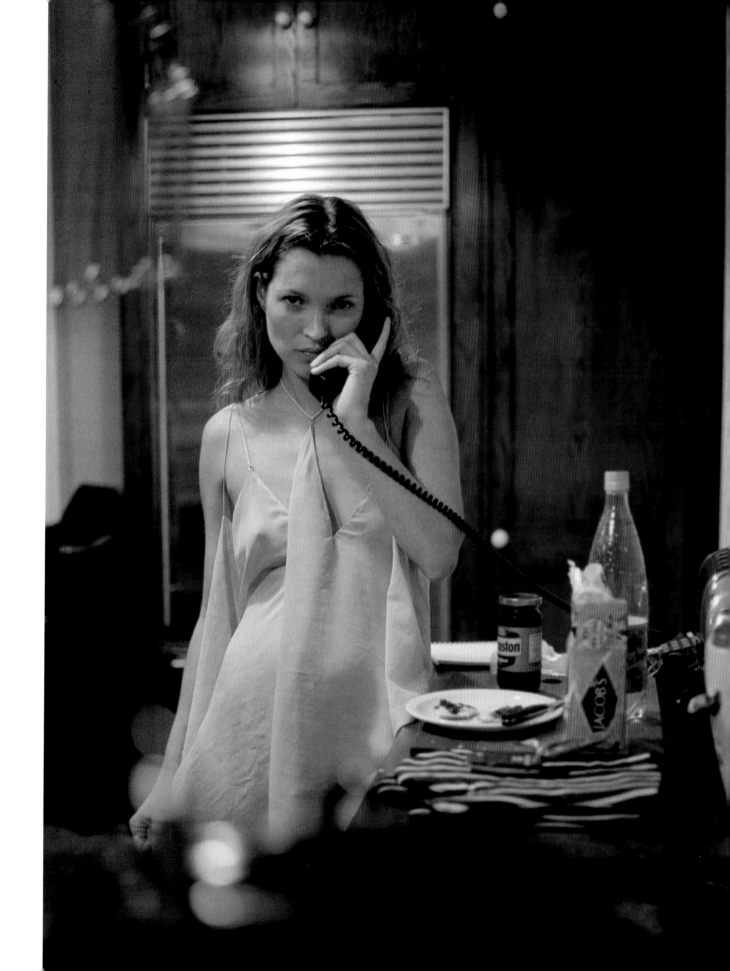

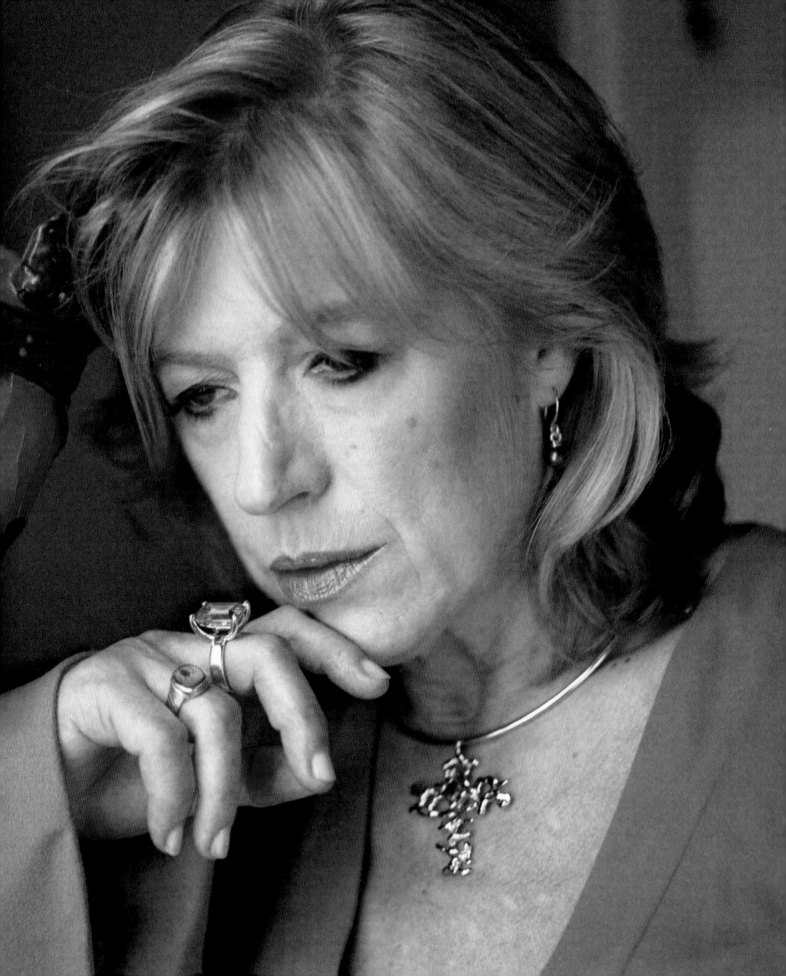

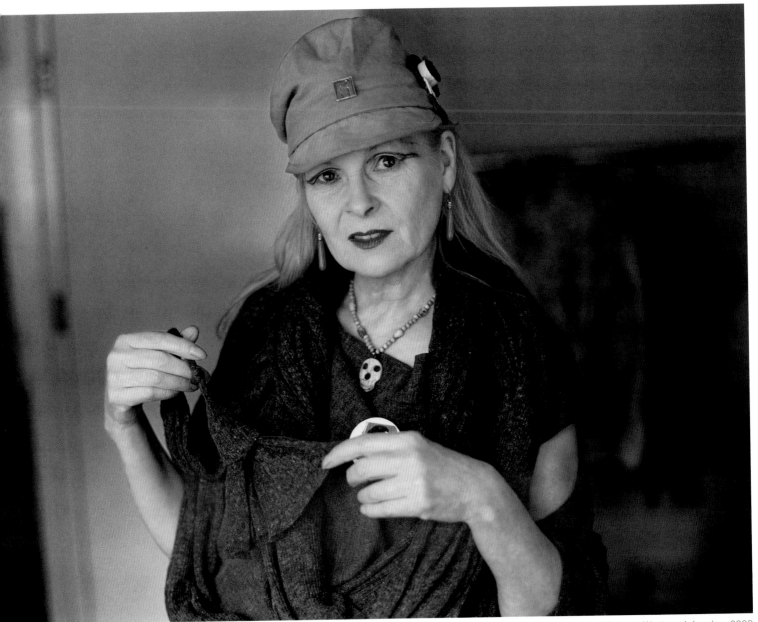

Vivienne Westwood, London, 2008

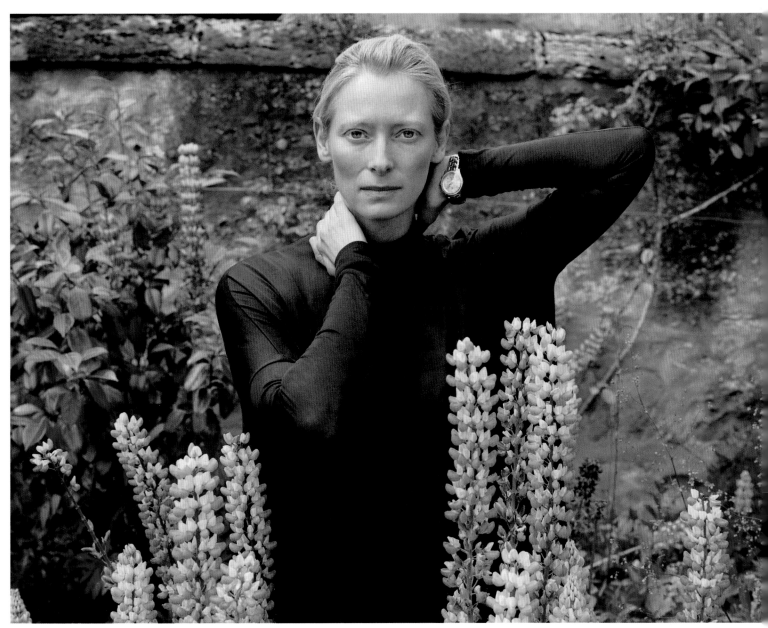

Tilda Swinton, Scotland, 2006

When I was invited to Chatsworth, I felt, as I always do, that I had to find something that conveyed the uniqueness of the sitter, in this case the Duchess of Devonshire. I found she had real serenity and elegance but with a wonderful pinch of English eccentricity, which I think comes through here.

"

Dowager Duchess of Devonshire, Chatsworth, Derbyshire, 2008

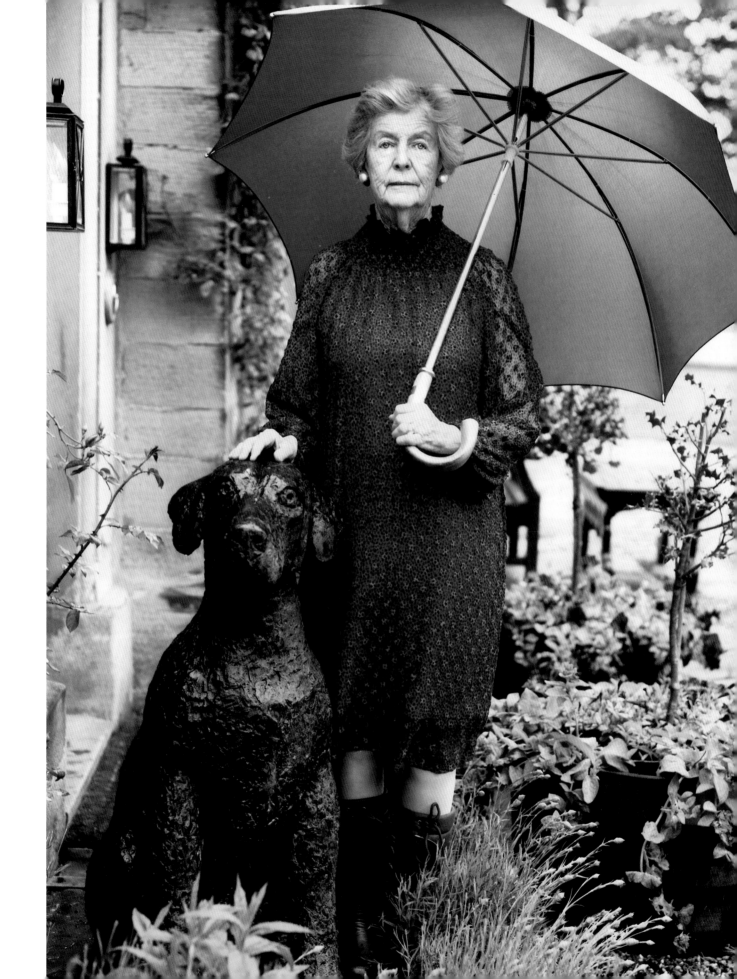

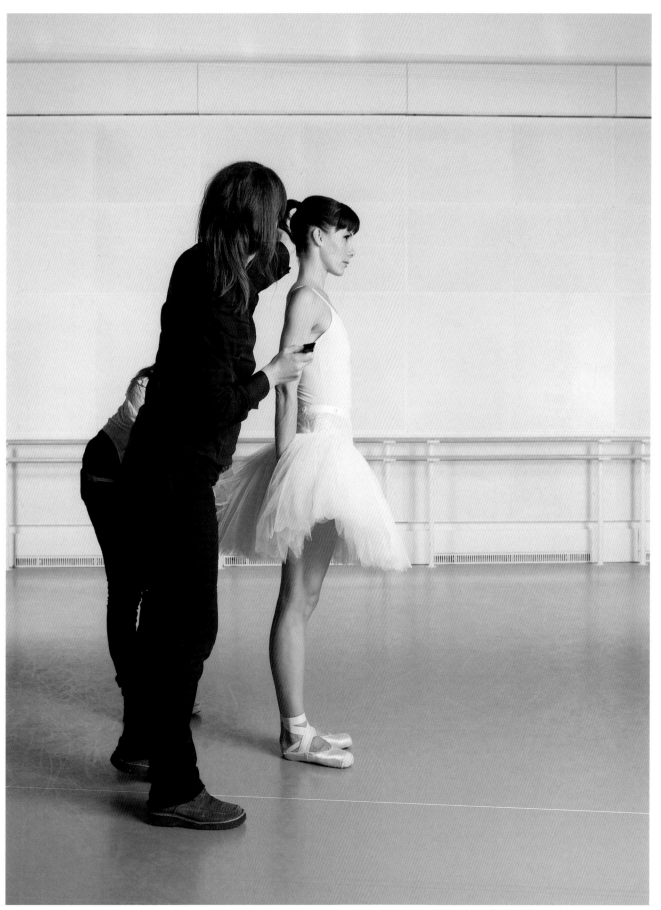

Darcey Bussell, Royal Opera House, London, 2006

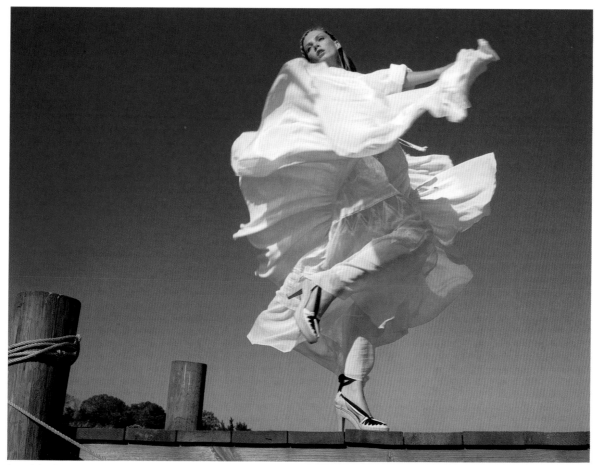

Long Island, 2004

My first commissioned
portrait. I pretended I
knew what I was doing –
but felt completely out
of my depth. I suppose
I just let her come to me
in the photo. I've been
doing it ever since. I love
her calm expression and
use of her hands, with
that naughty tattoo. I
always wondered what
that tattoo is all about.

"

Helen Mirren, London, 1998

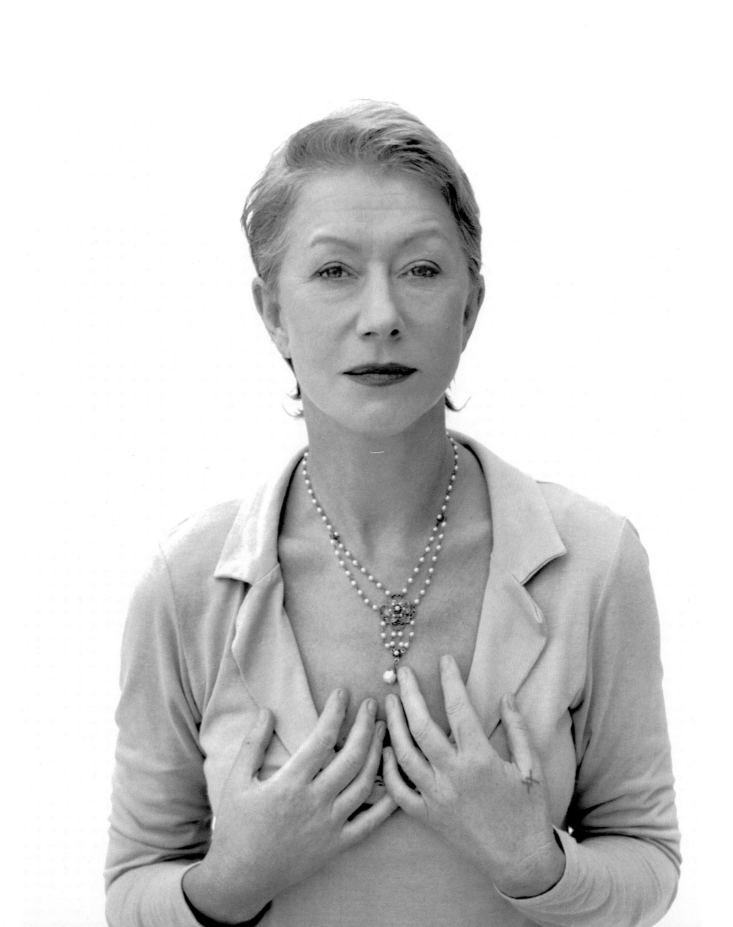

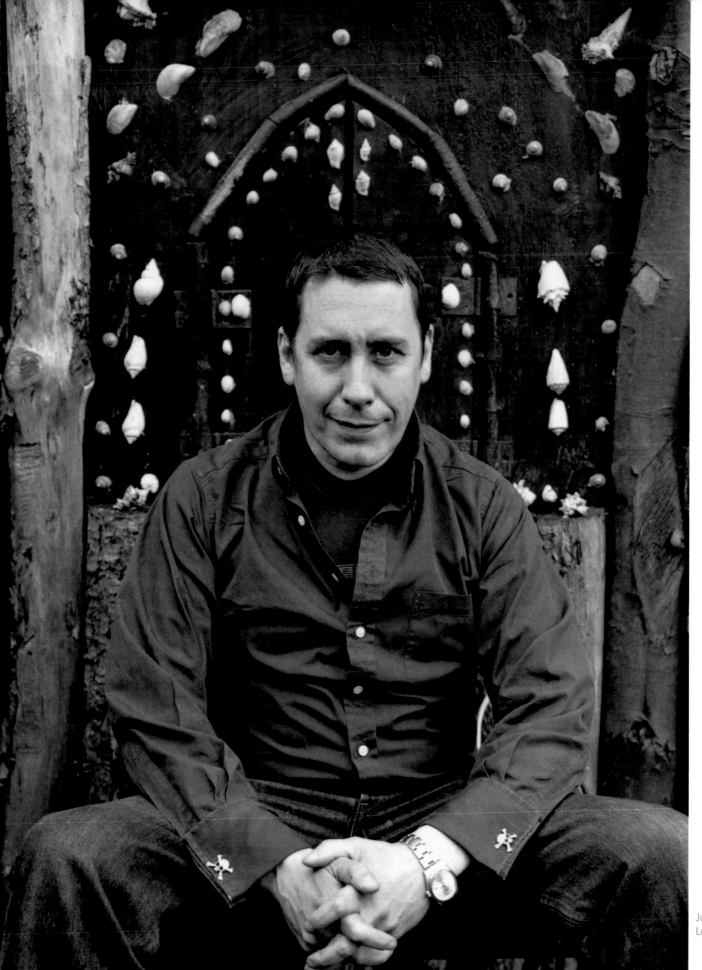

Jools Holland,
London, 2000

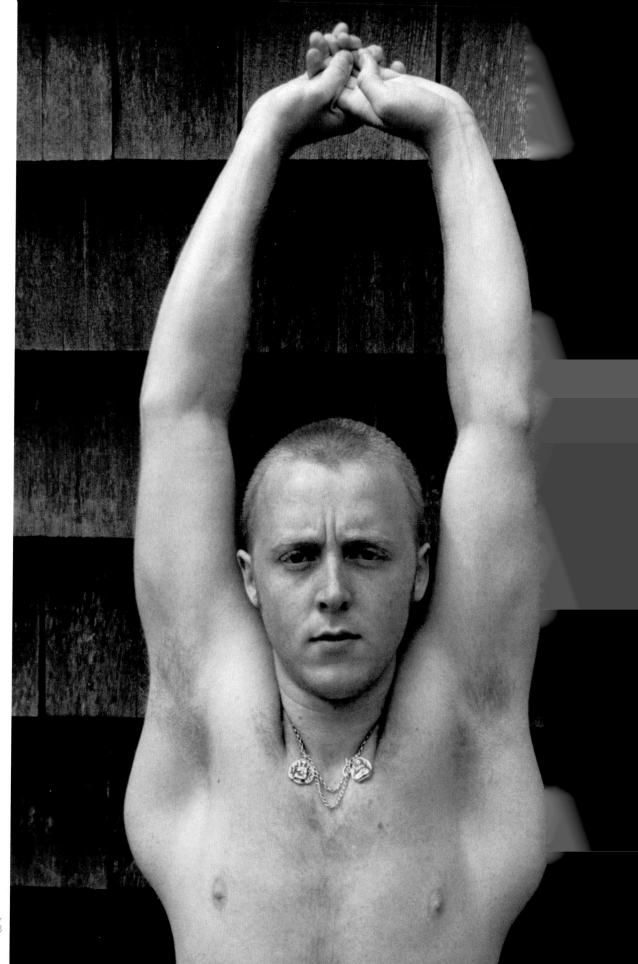

James,
Long Island, 1998

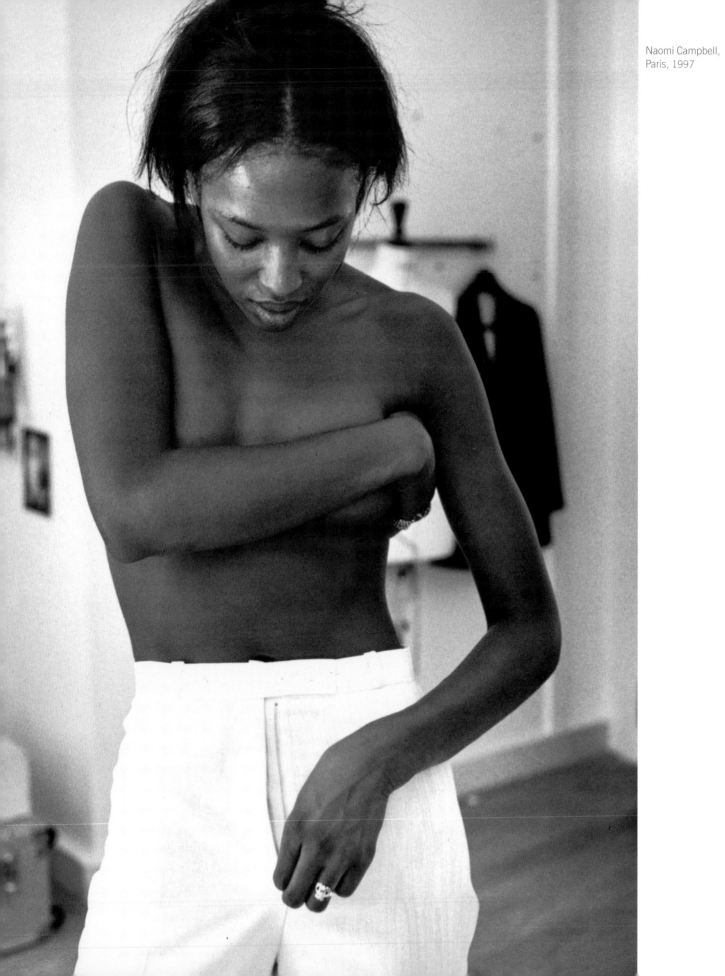

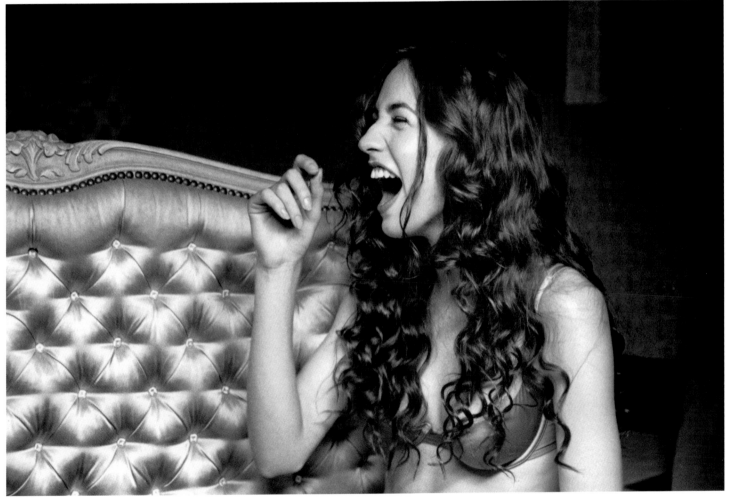

Elizabeth Jagger, London, 2003

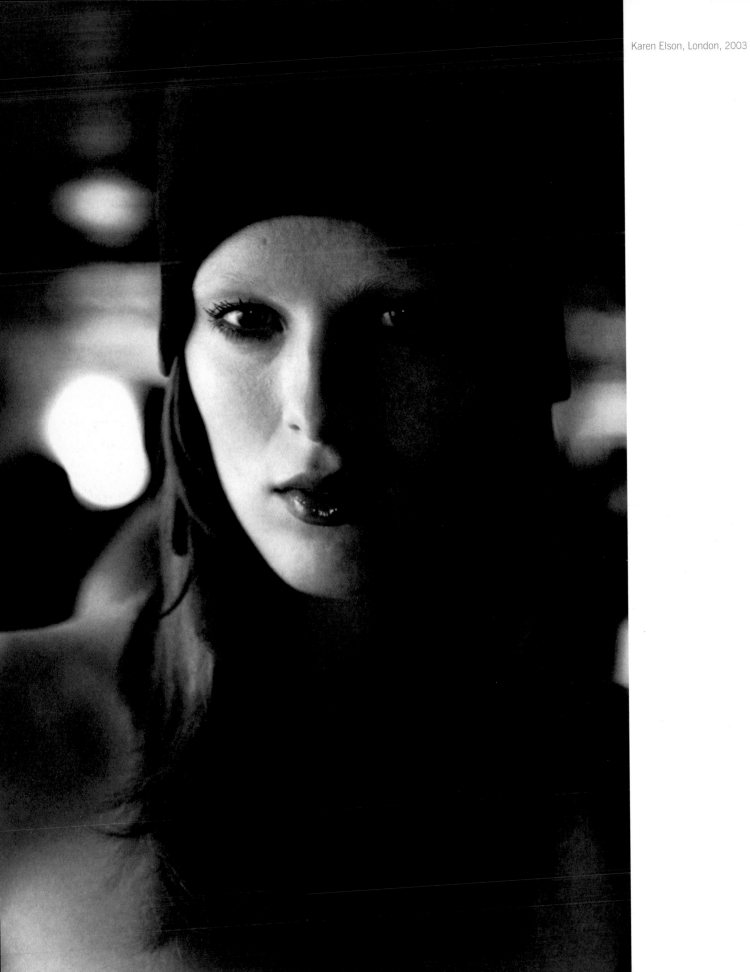

Karen Elson, London, 2003

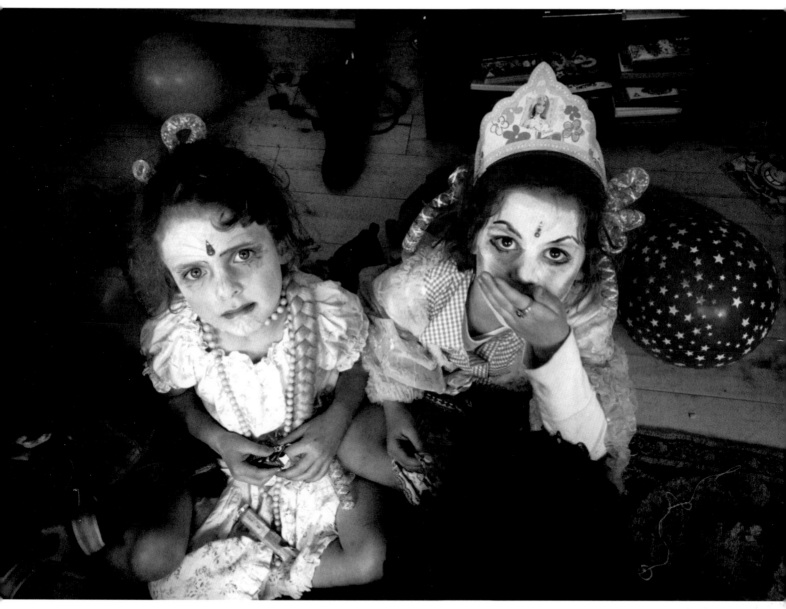

London, 2003

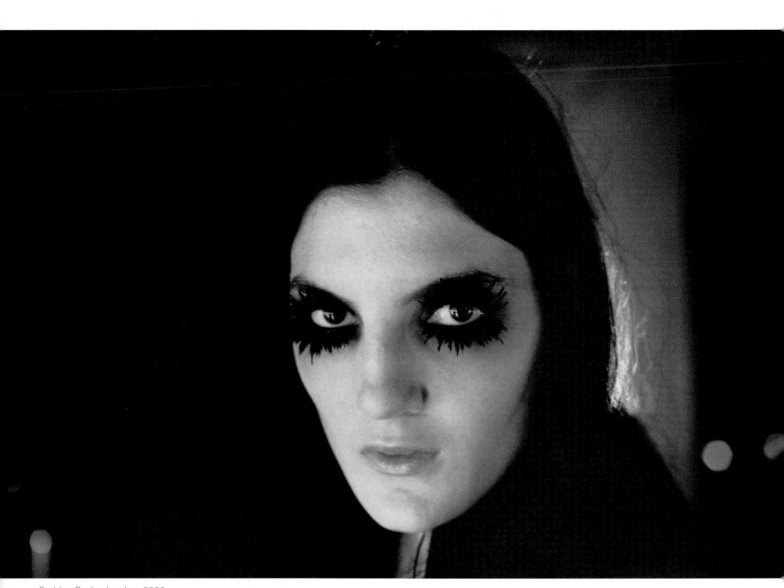

Fashion Rocks, London, 2003

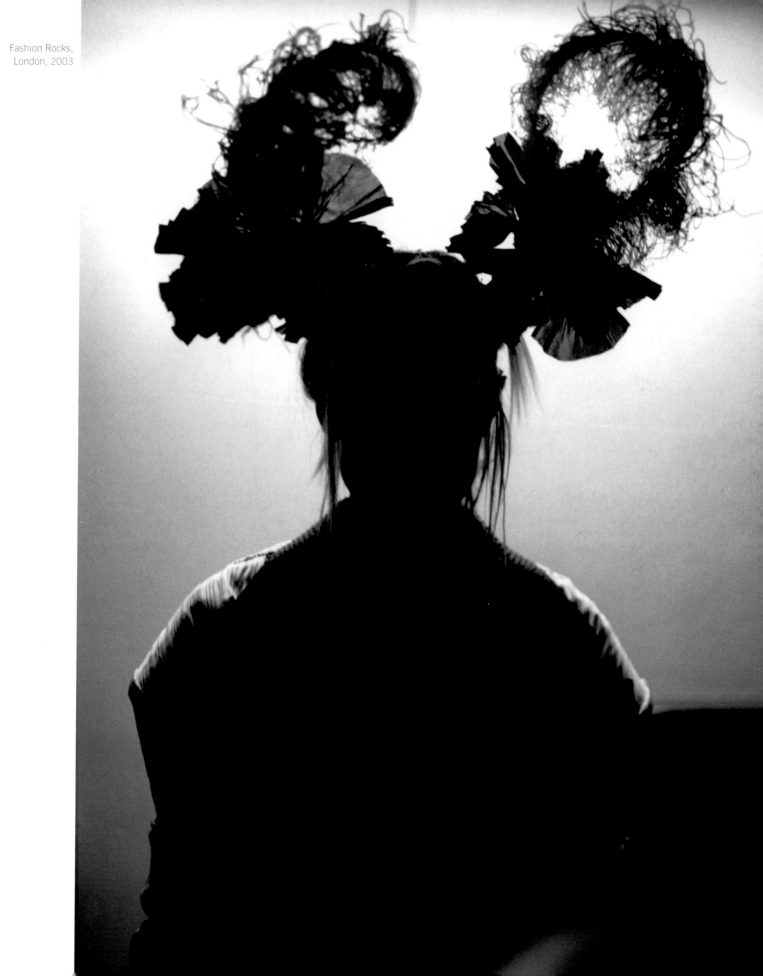

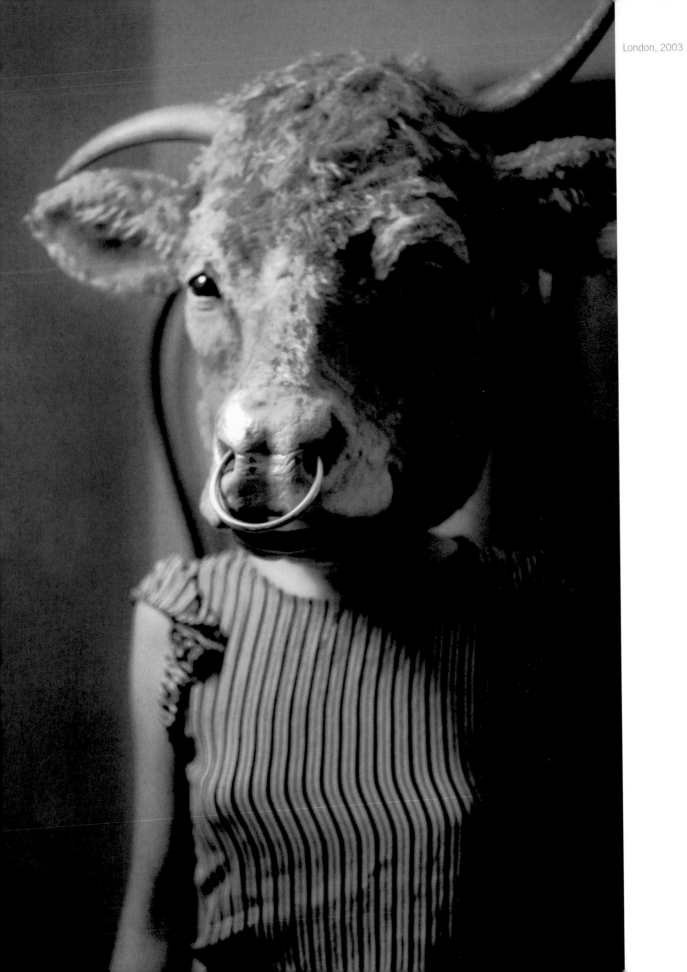

Paris, 2005

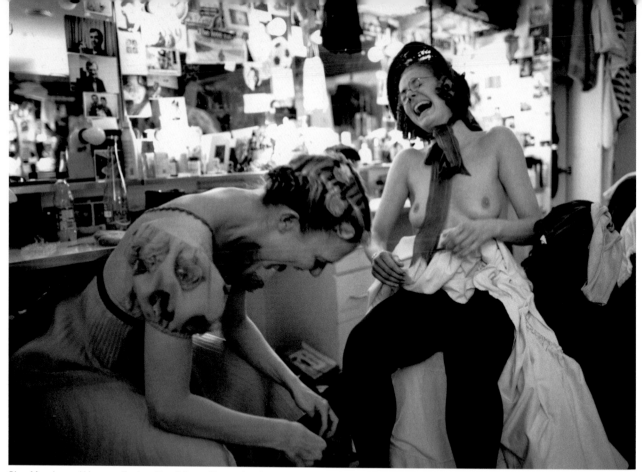

Sian Murphy and Vanessa Fenton, Royal Opera House, London, 2004

London, 2000

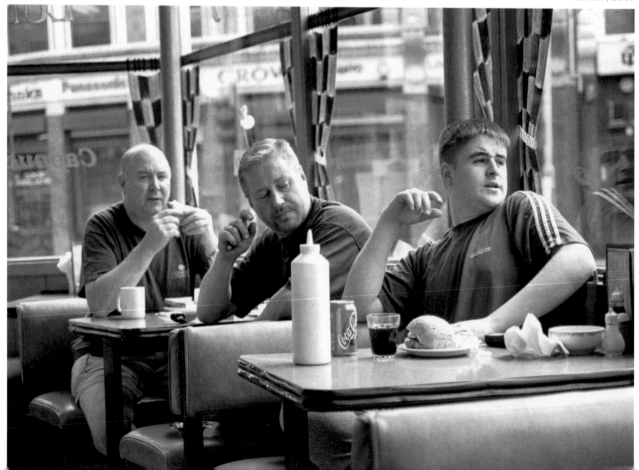

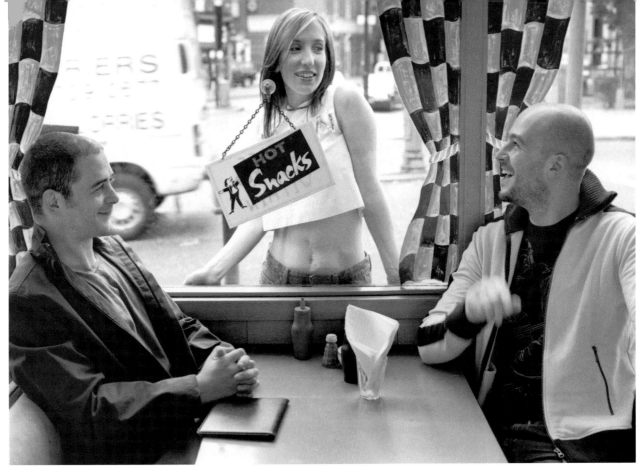

Sam Taylor-Wood and Jake and Dinos Chapman, London, 2000

Nashville, 2003

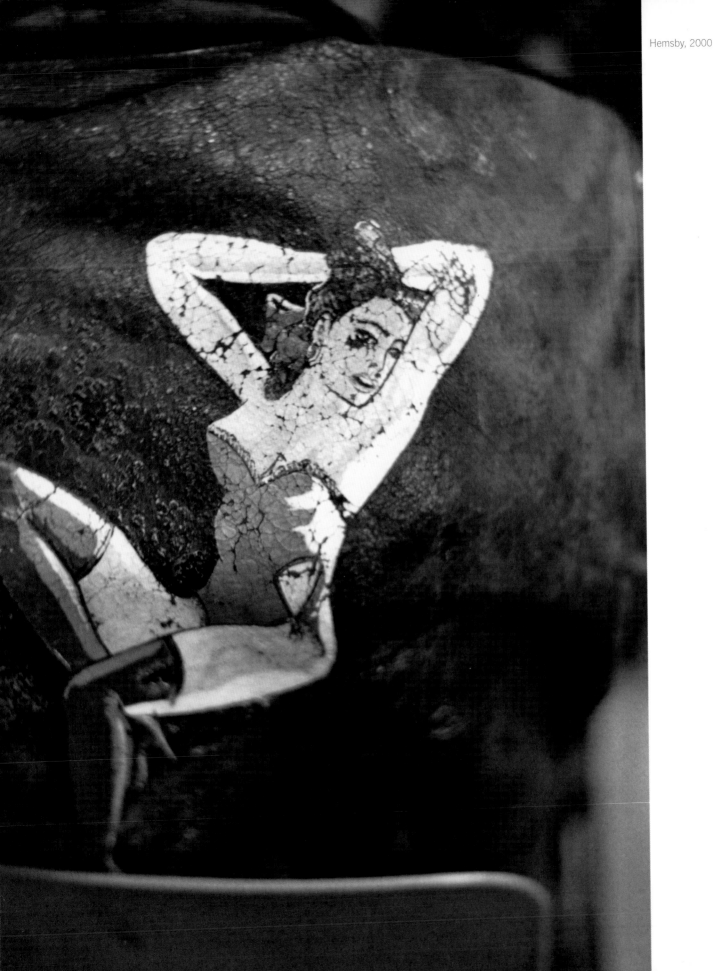

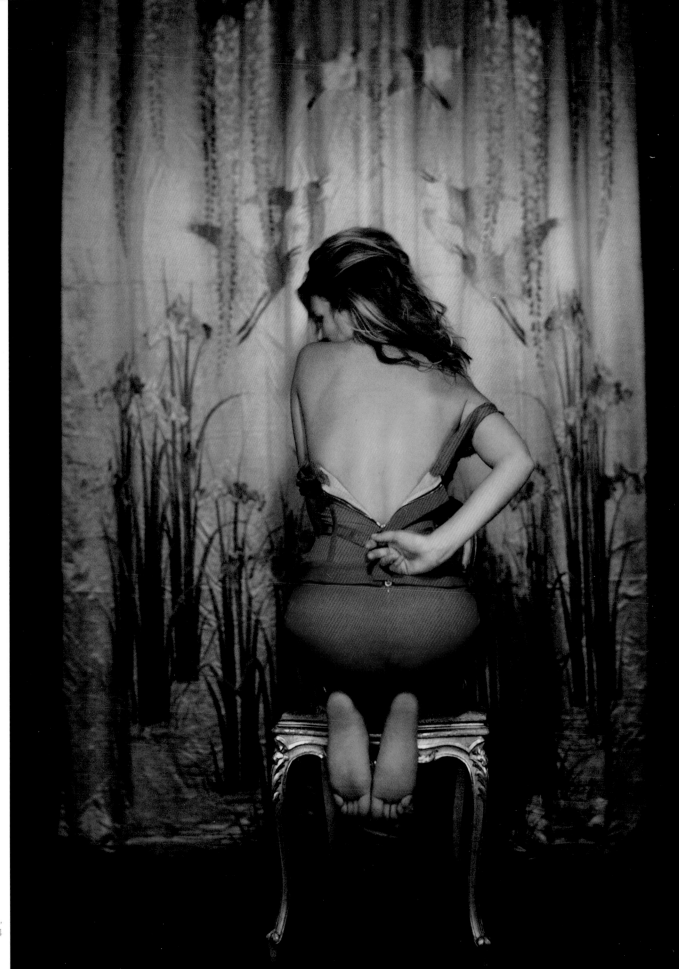

Kate Moss,
London, 2004

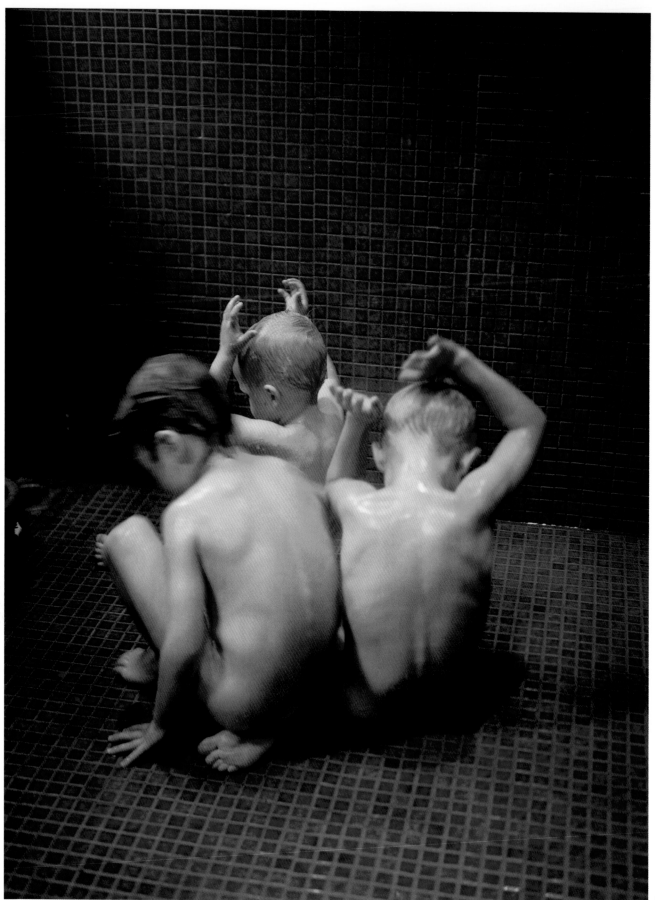

Sussex, 2004

Dylan, Jamaica, 2005

Long Island, 2006

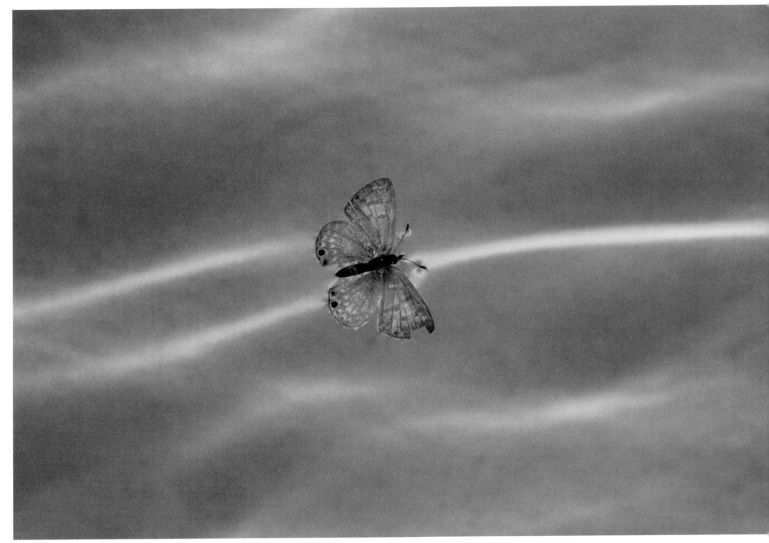

Arizona, 2003

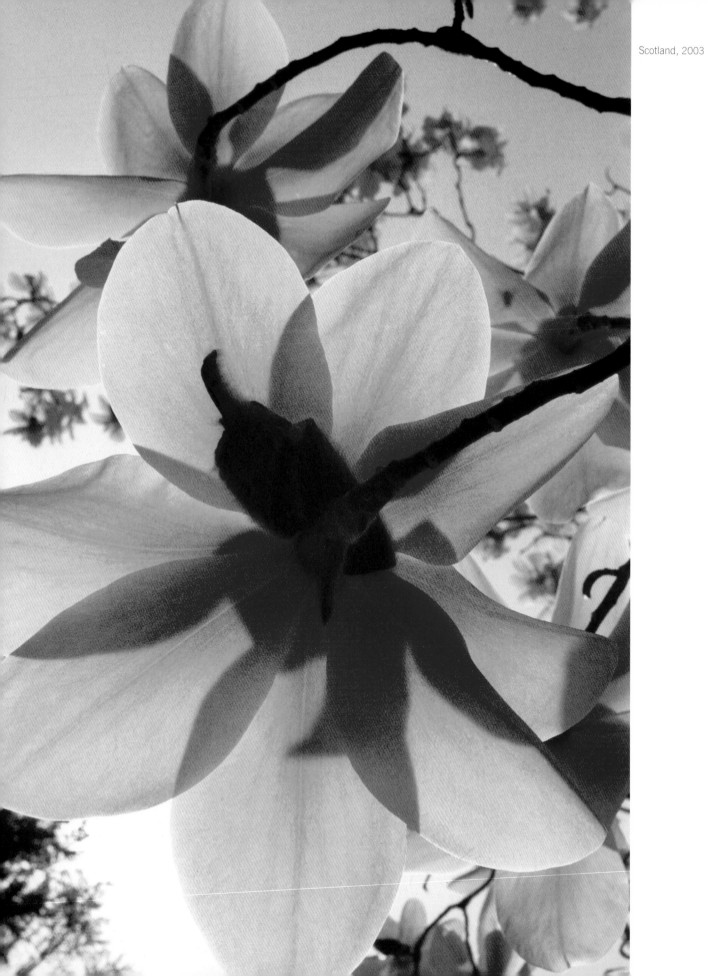

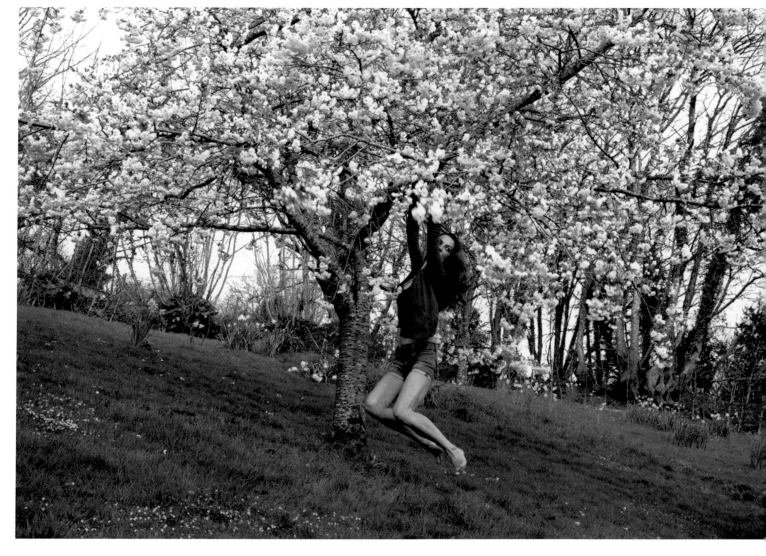

Stella, Long Island, 2006

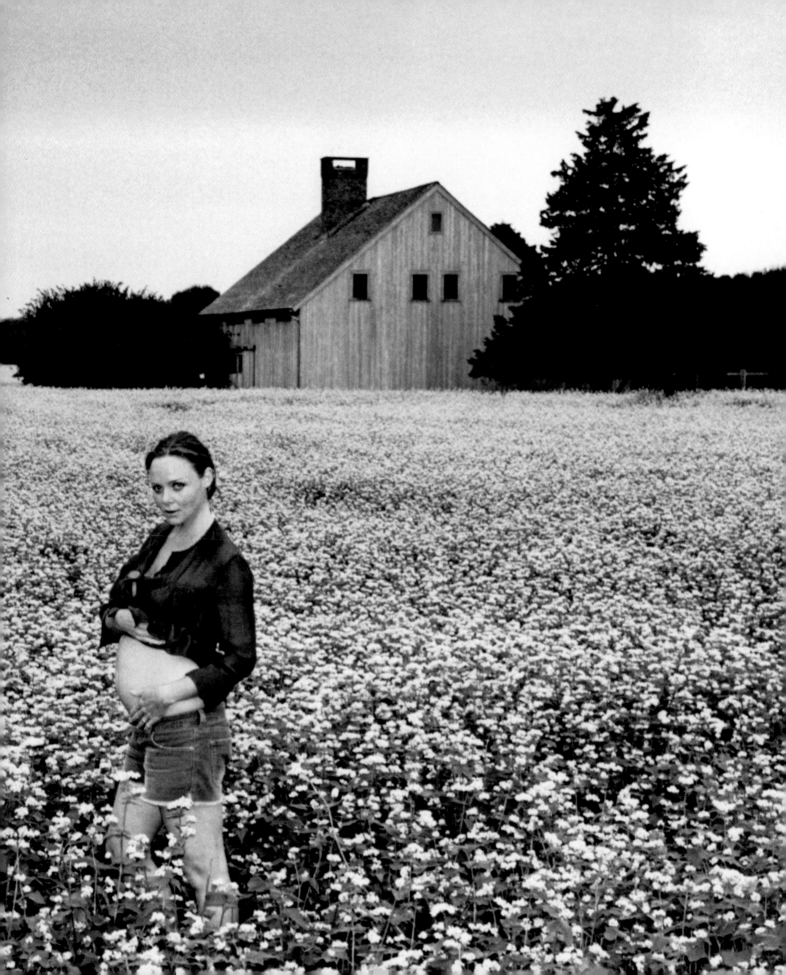

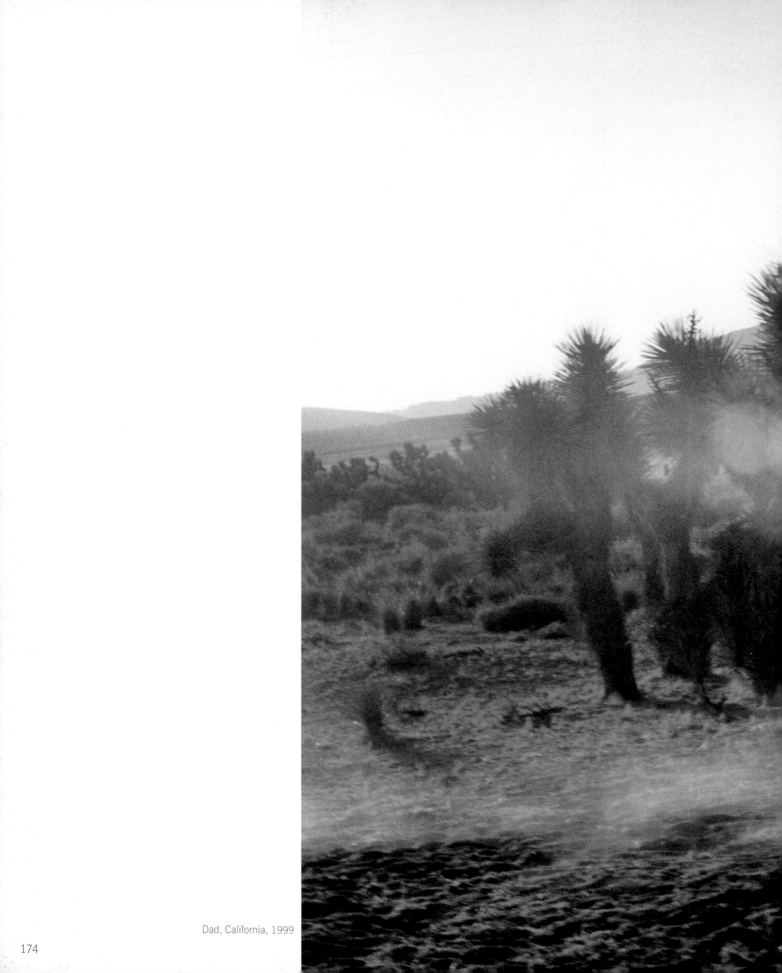

Dad, California, 1999

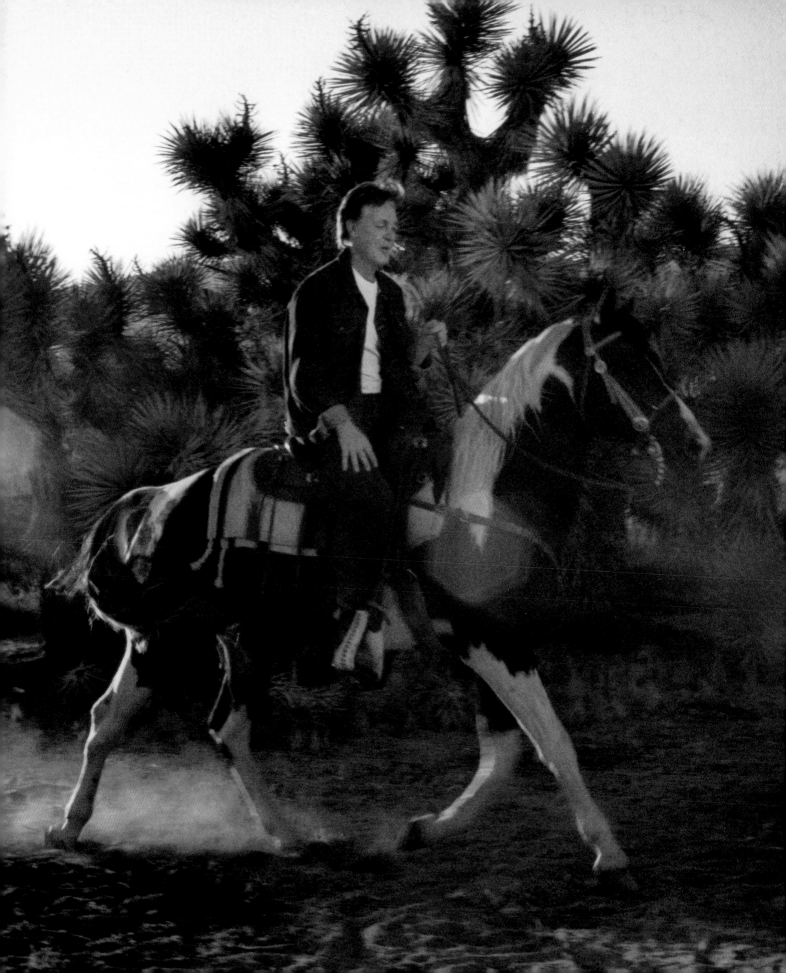

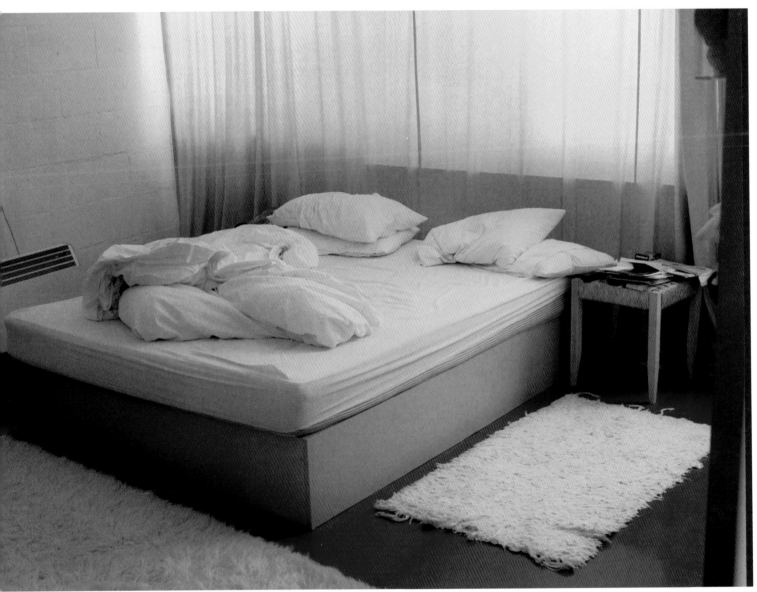

Tracey's bed, London, 2000

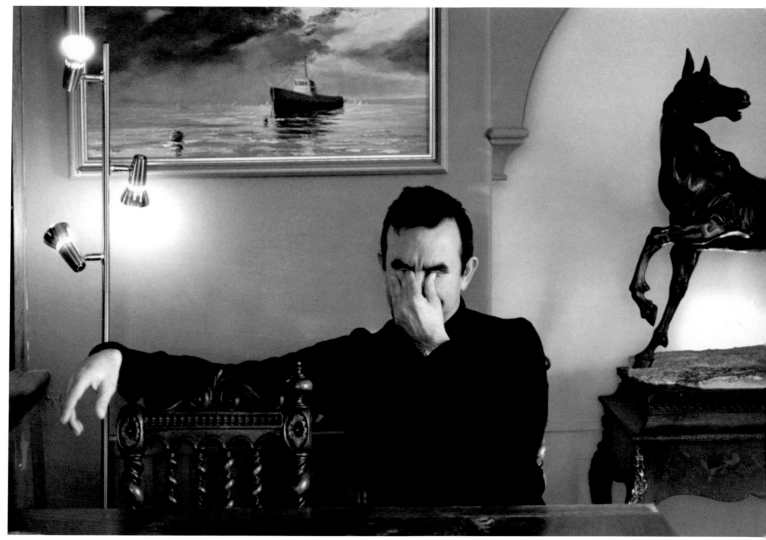

Simon, Norfolk, 2007

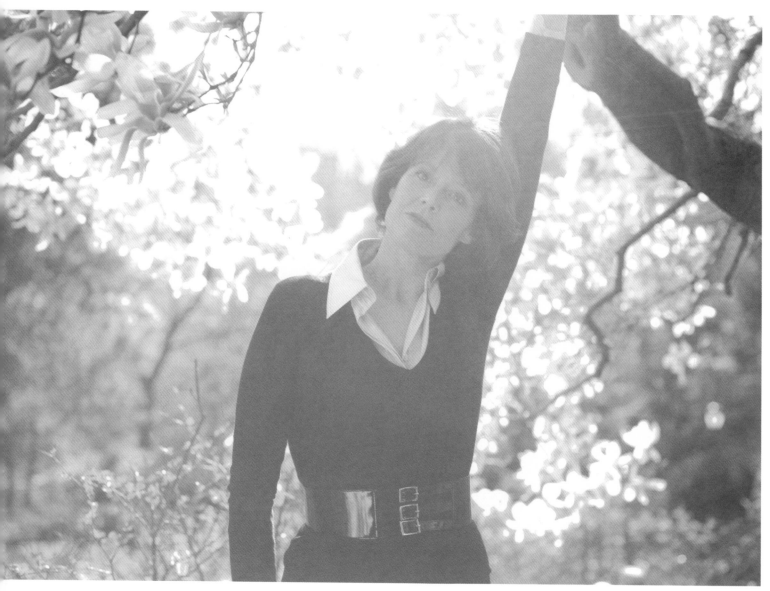

Sigourney Weaver, New York City, 2008

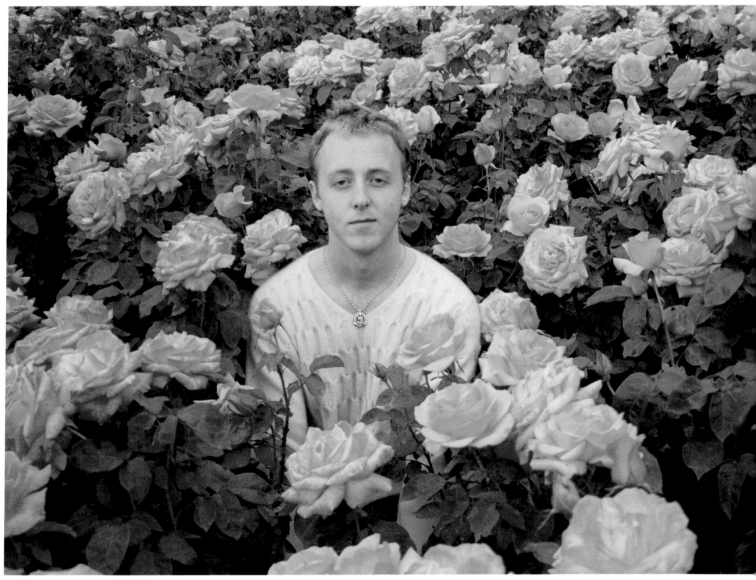

James, London, 2000

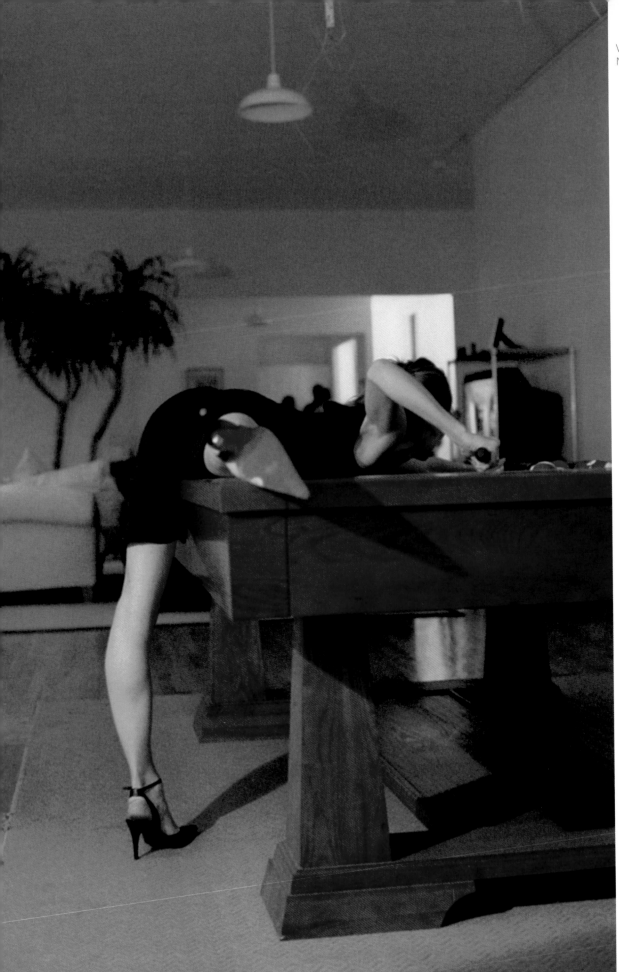

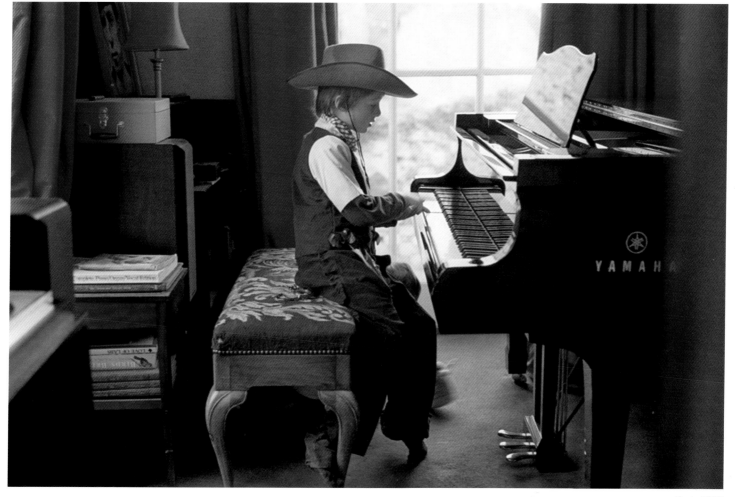

Kent, 2007

Sir Ian McKellen, London, 2008

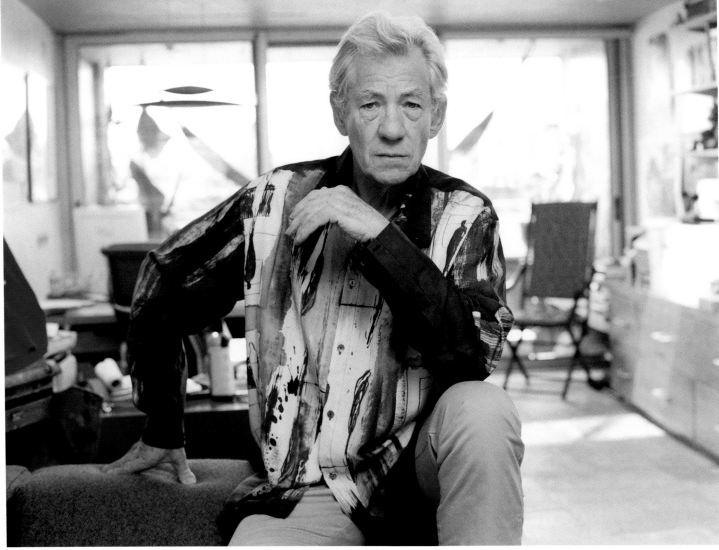

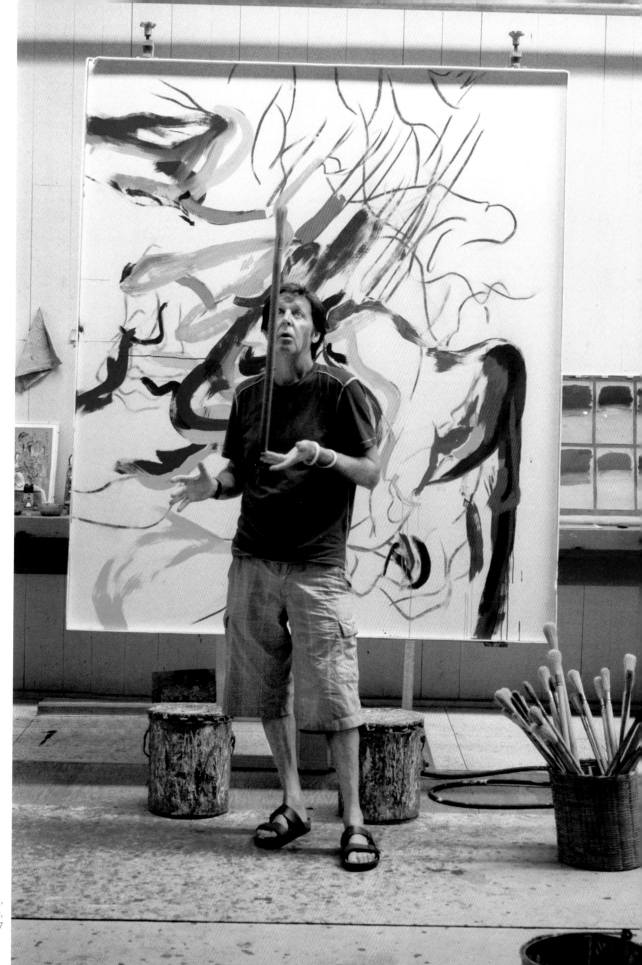

Dad,
Willem de Kooning studio,
Long Island, 2007

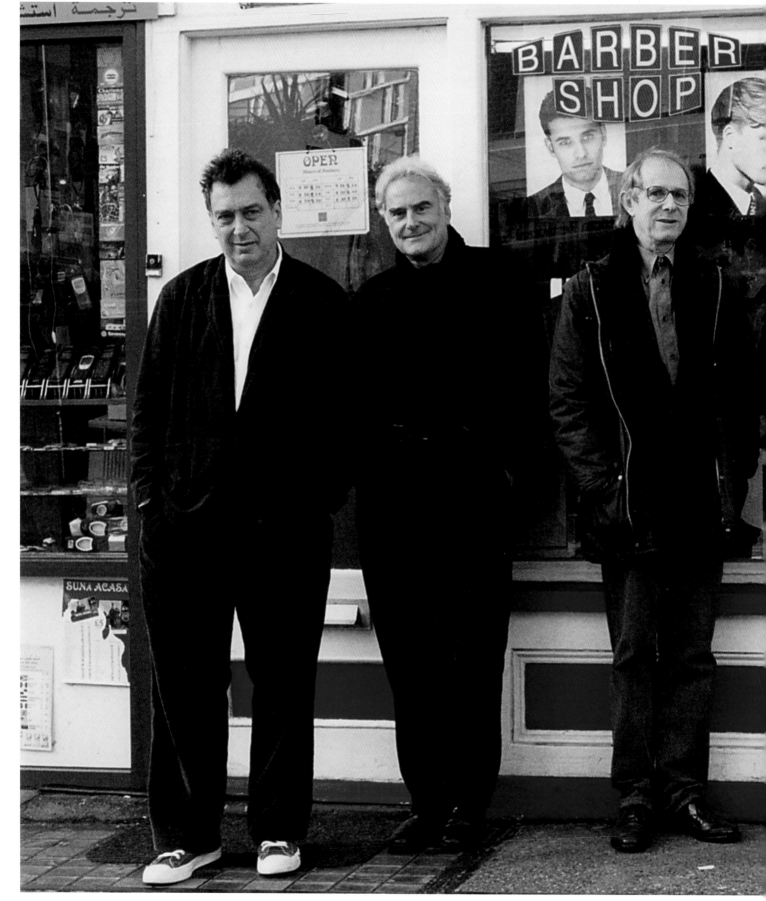

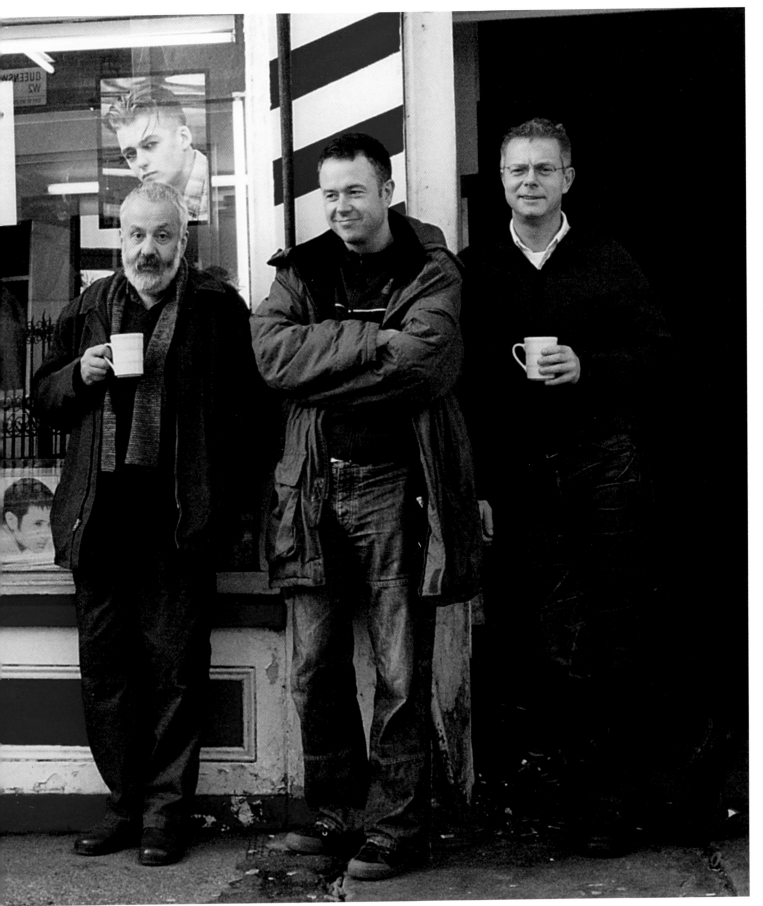

London, 2006

Mum's paperweights, Sussex, 1997

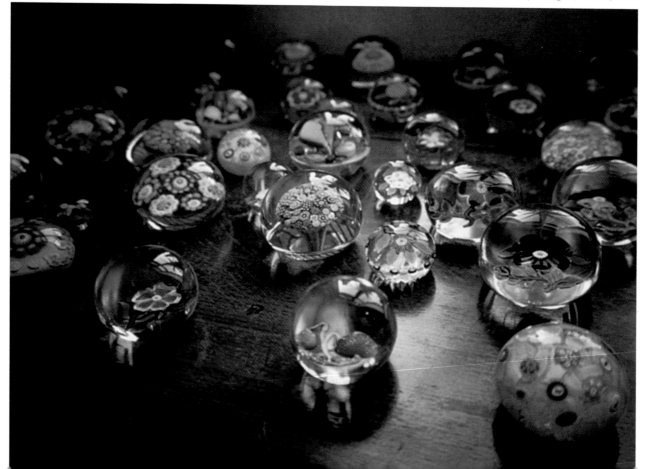

Sussex, 2008

Oxfordshire, 2005

London, 2008

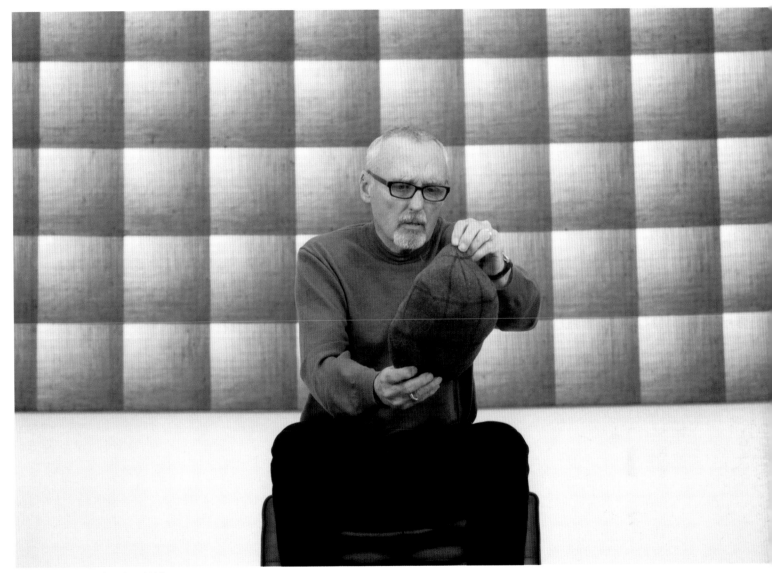

Dennis Hopper, Los Angeles, 2008

Dave and Neesy, Hemsby, 2000

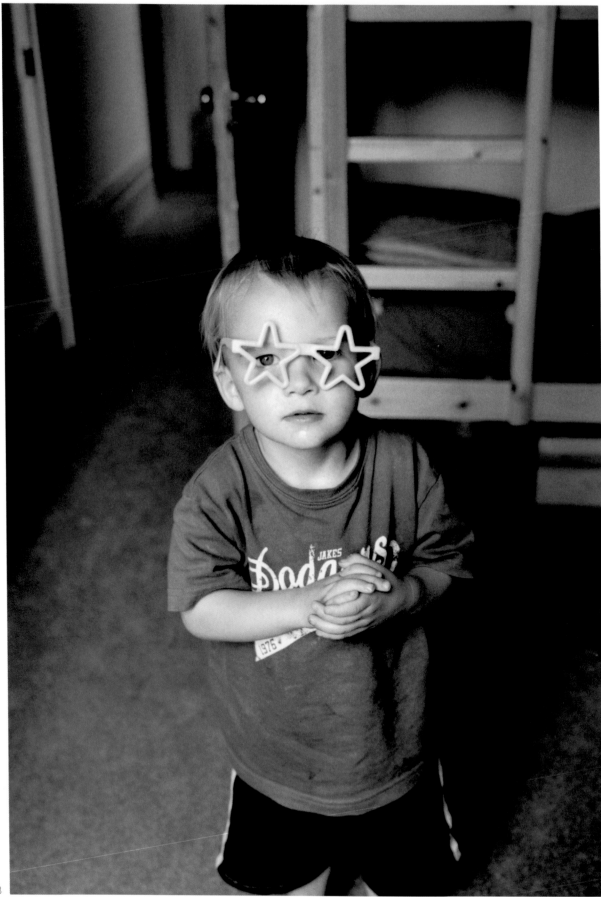

London, 2003

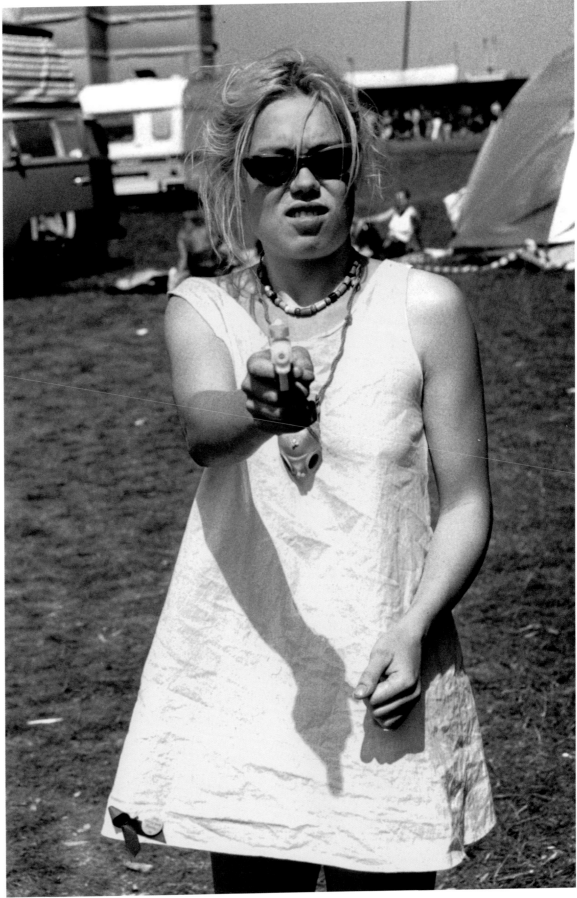

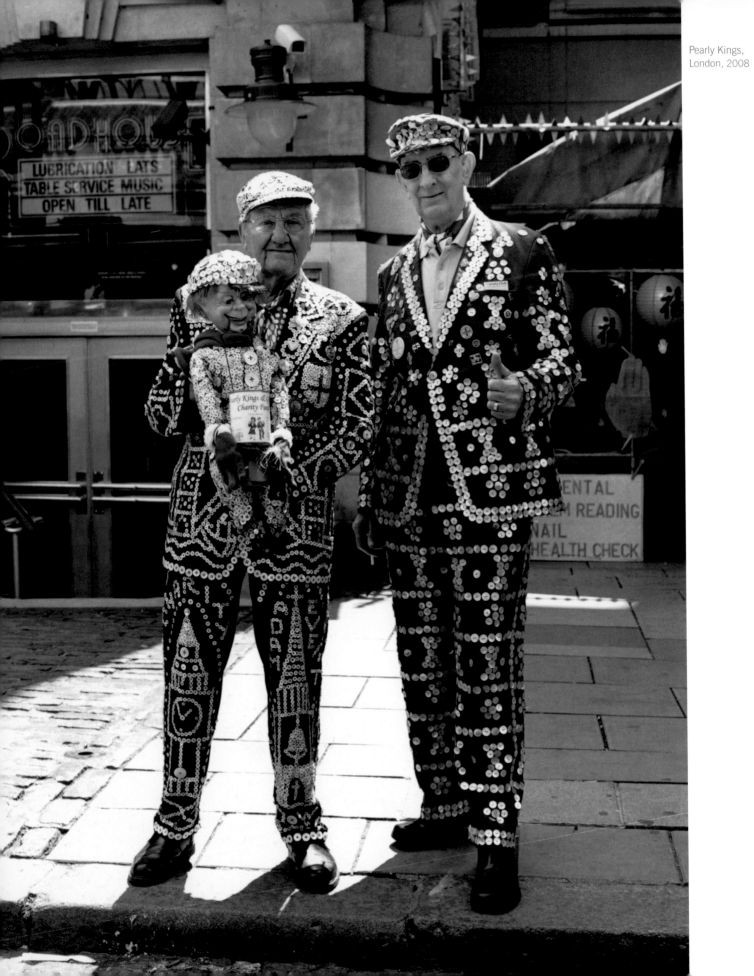

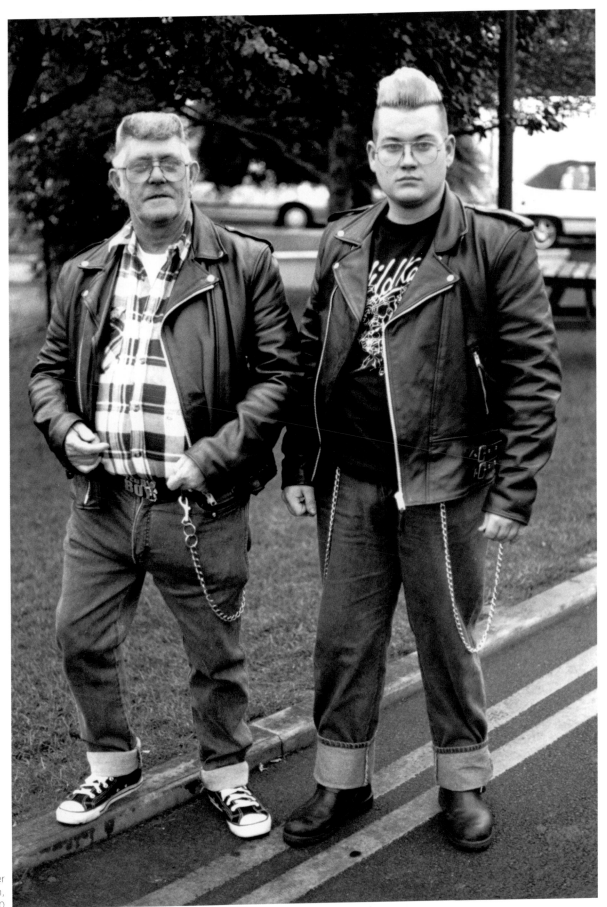

Grandfather
and grandson,
Hemsby, 2000

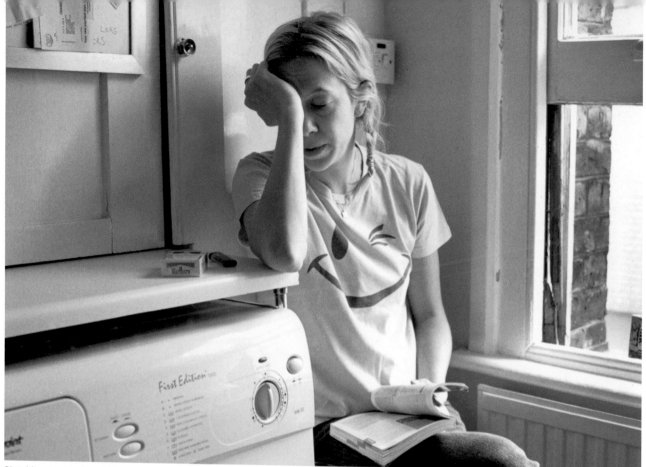

Sian Murphy, London, 2004

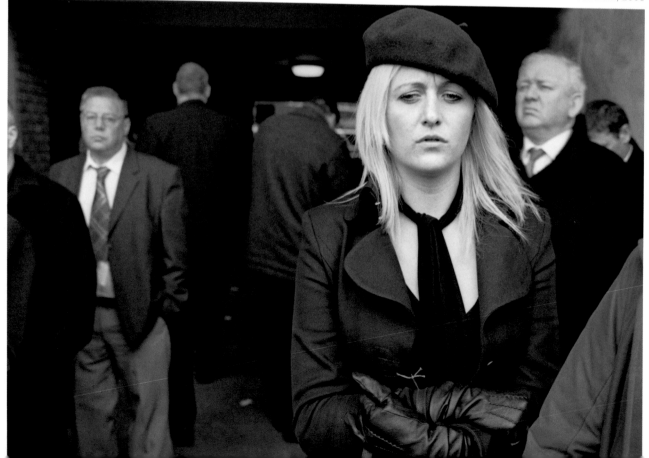

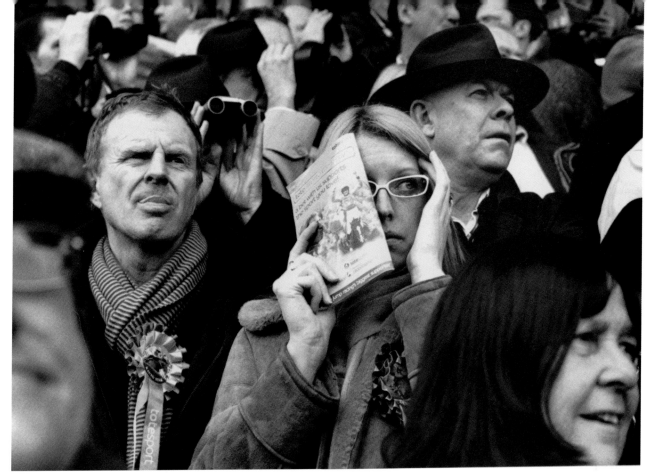

Cheltenham, 2008

Royal Festival Hall, London, 2003

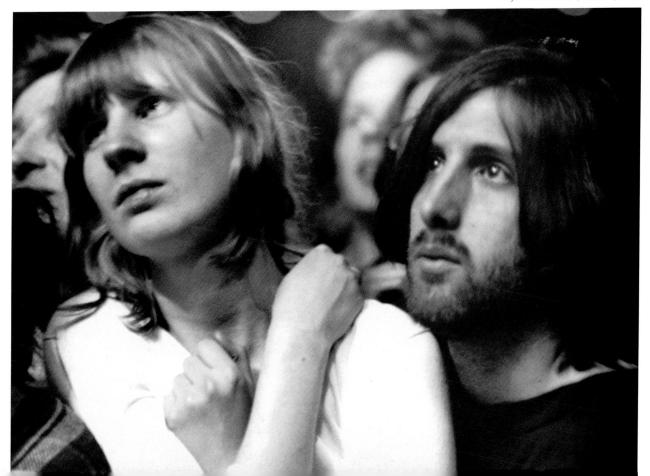

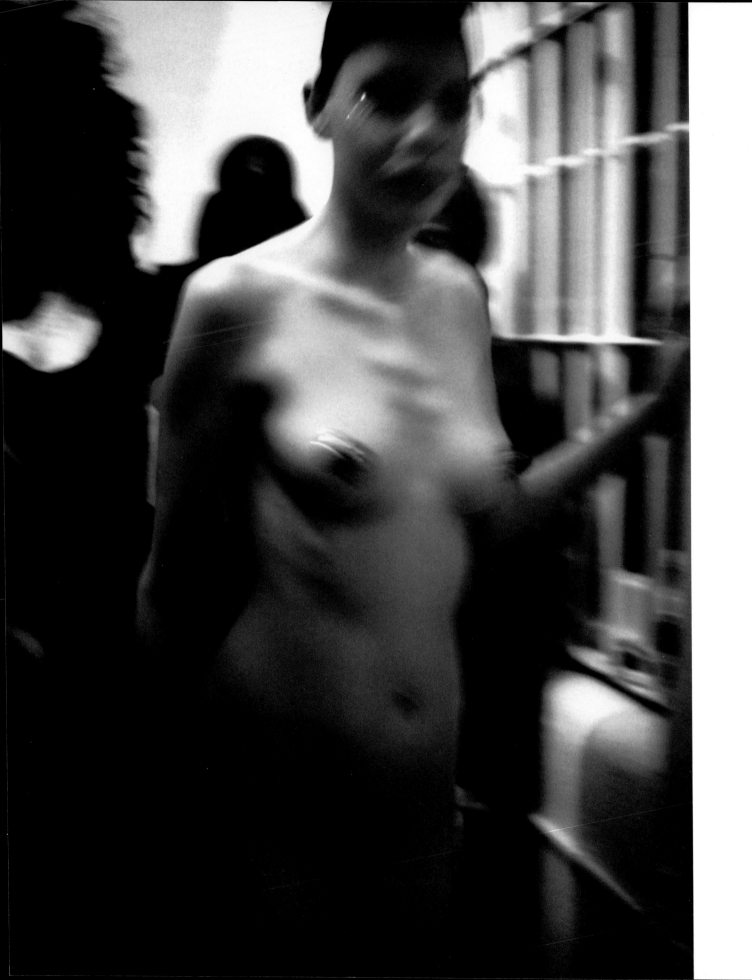

Simon, New York City, 2008

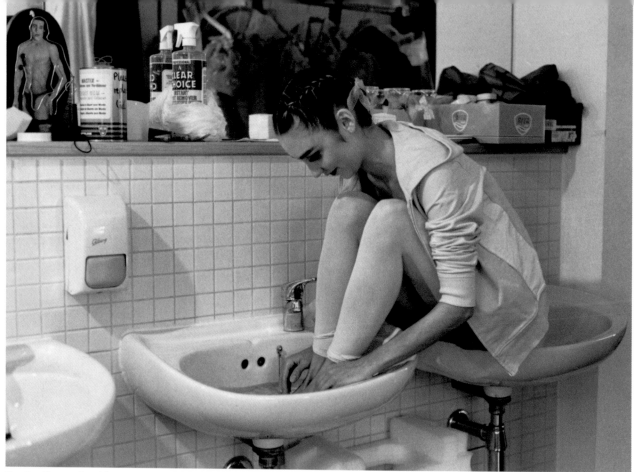

Caroline Duprot, Royal Opera House, London, 2004

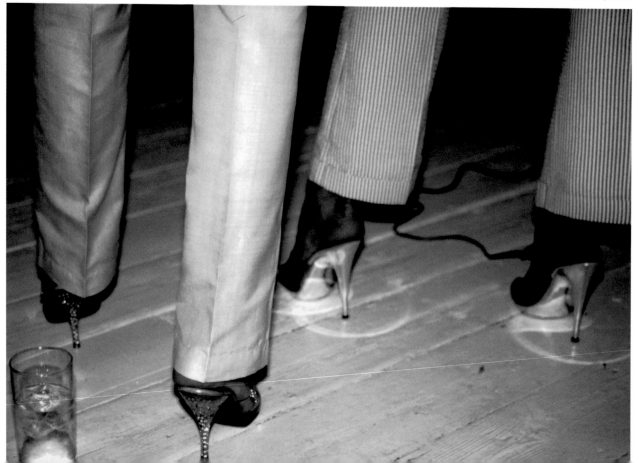

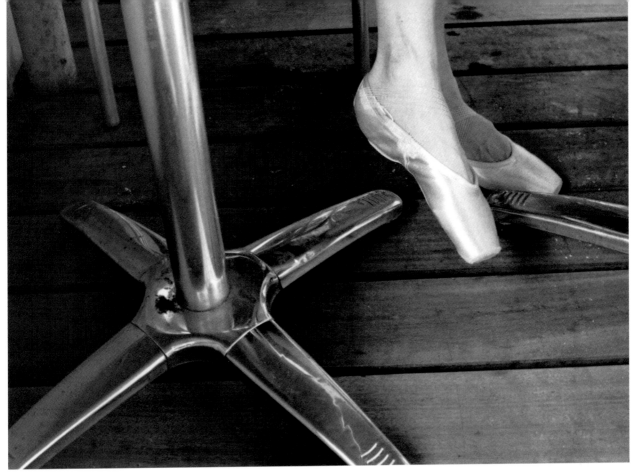

Royal Opera House, London, 2004

Ballerina feet, London, 2004

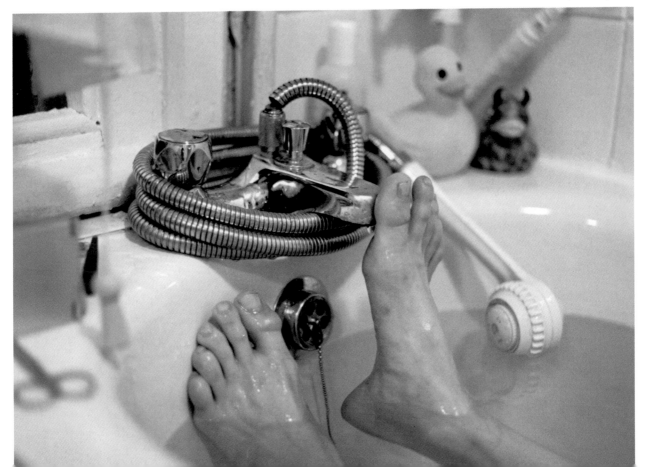

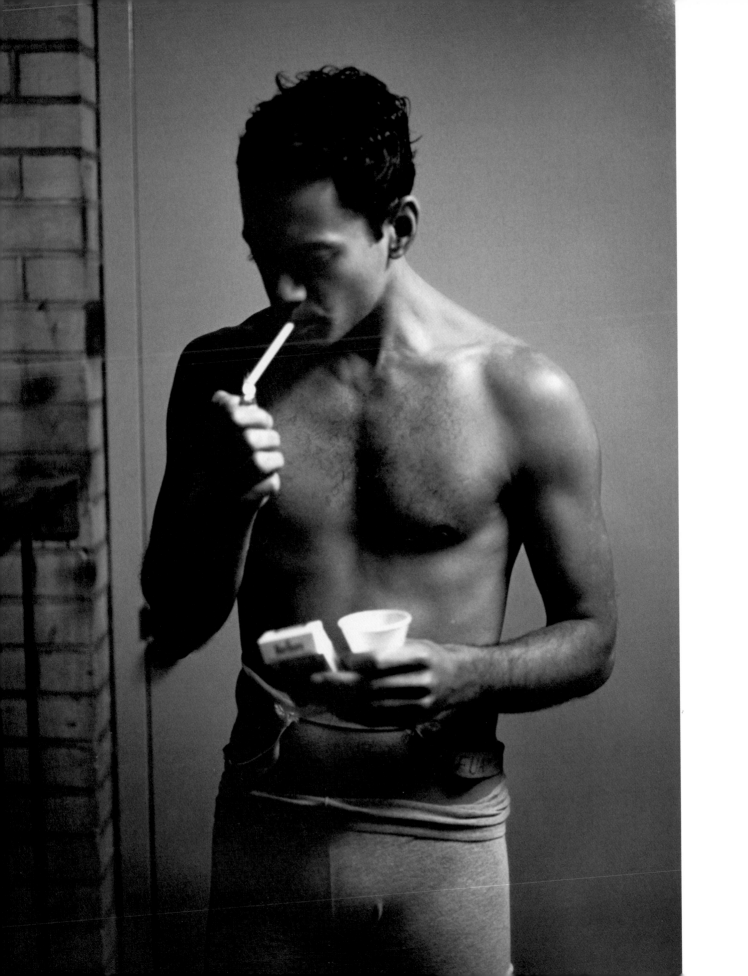

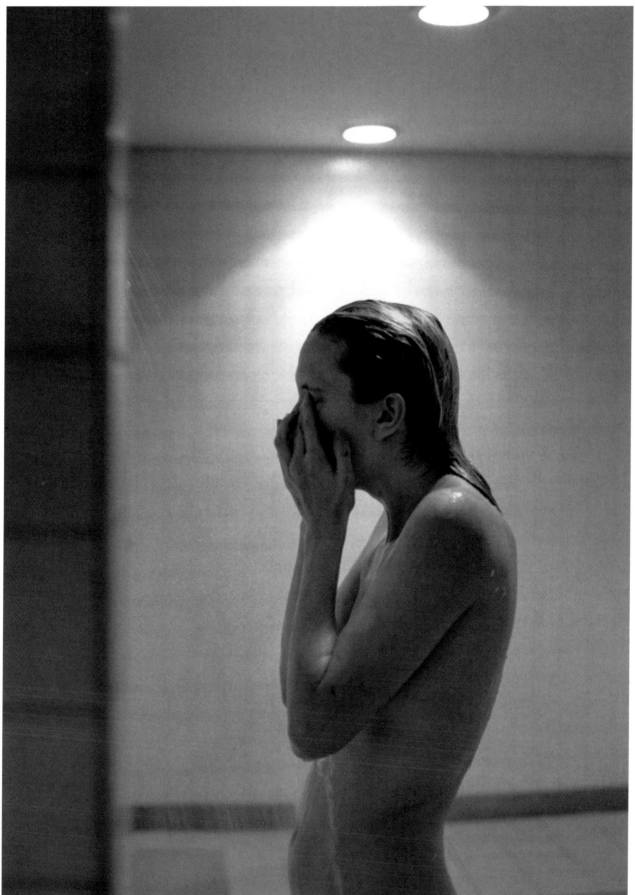

Sian Murphy, Royal Opera House, London, 2004

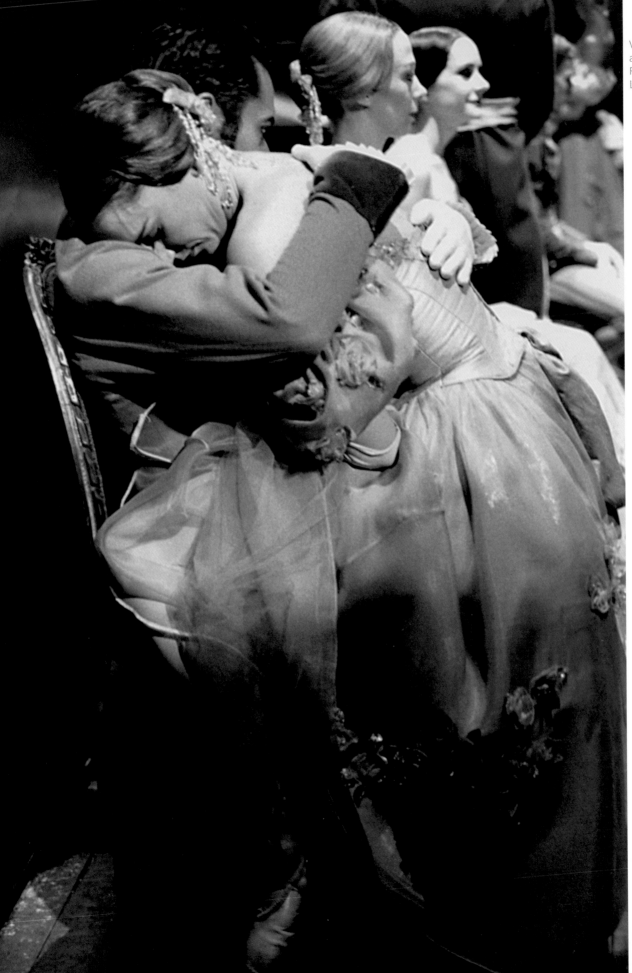

Victoria Hewitt
and Josh Tuifua,
Royal Opera House,
London, 2004

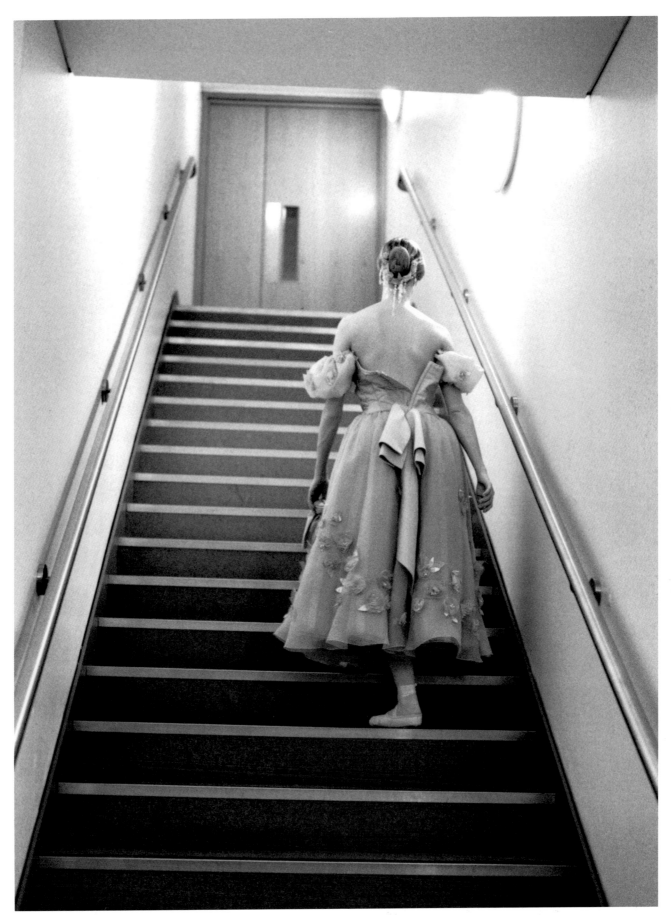

Royal Opera House, London, 2004

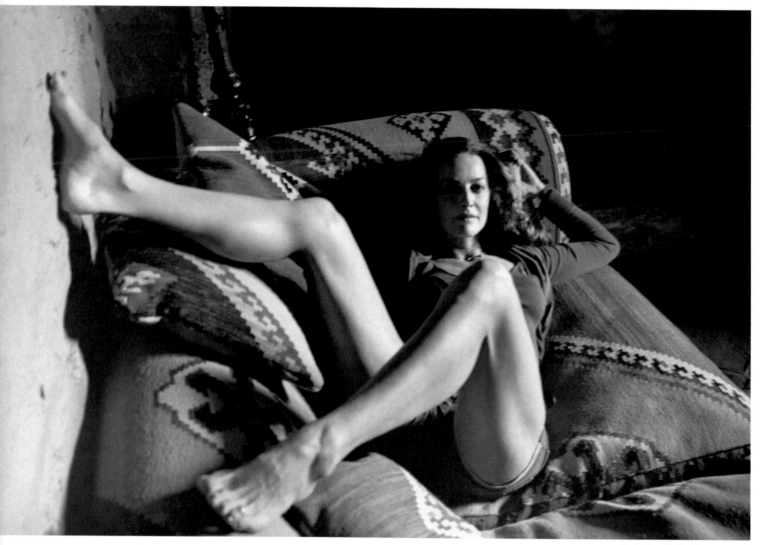

Catherine Bailey, Devon, 2008

London, 1999

London, 1999

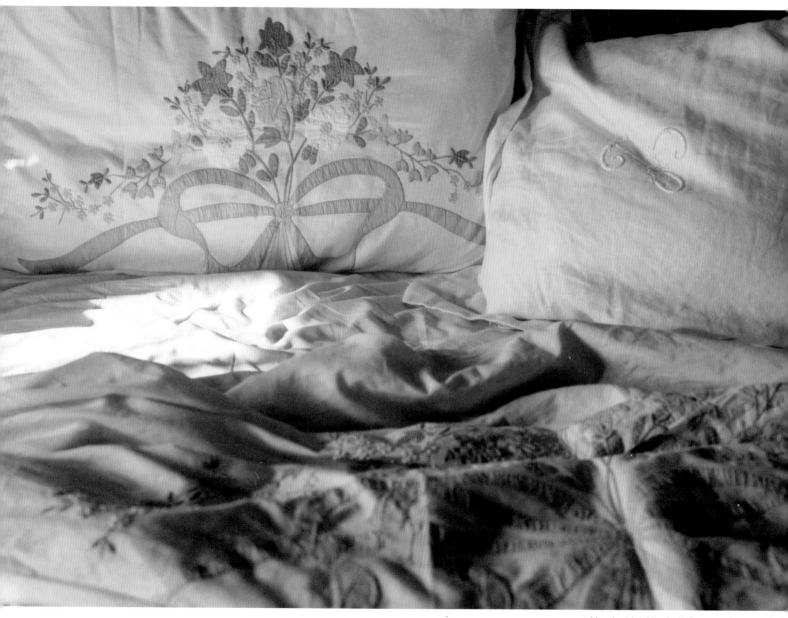

Mum's side of the bed, Sussex, 1998

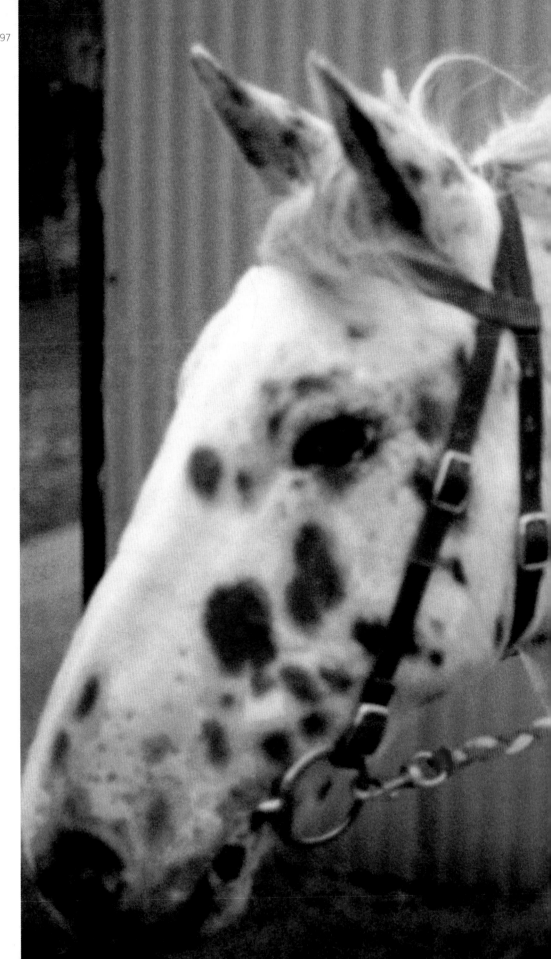

Stella, Sussex, 1997

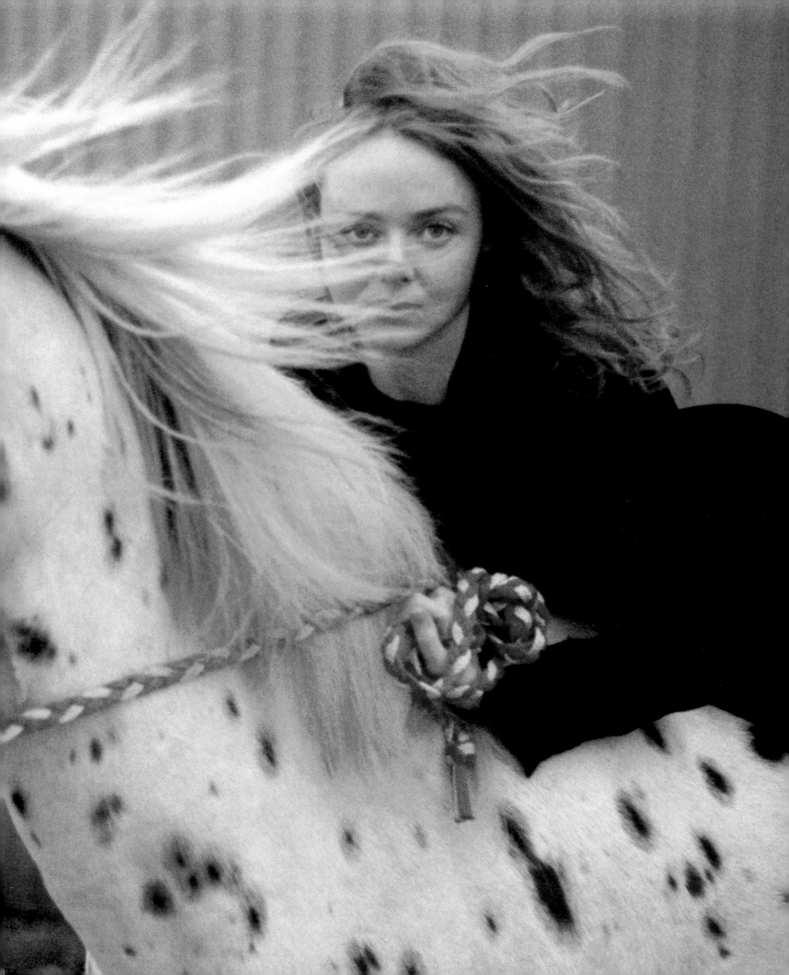

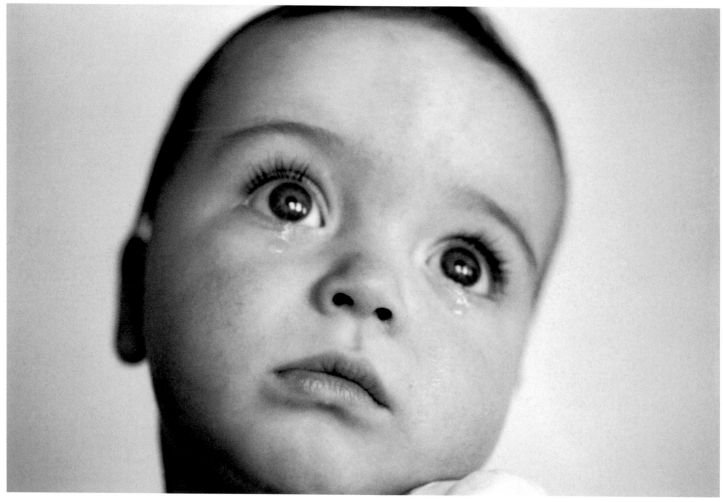

London, 2009

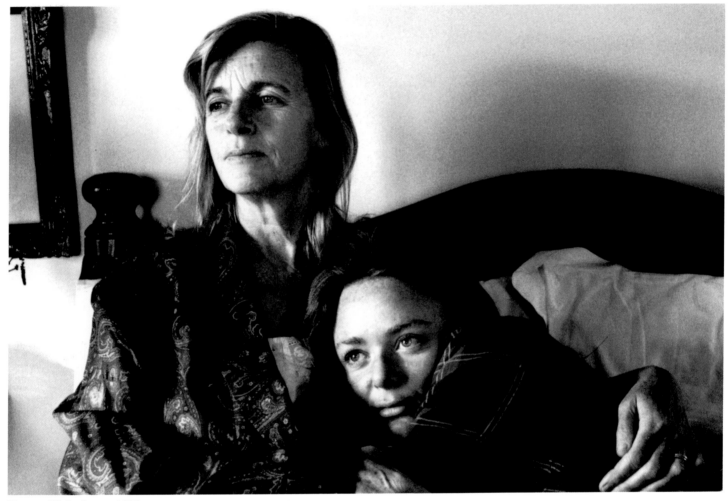

Mum and Stella, Sussex, 1995

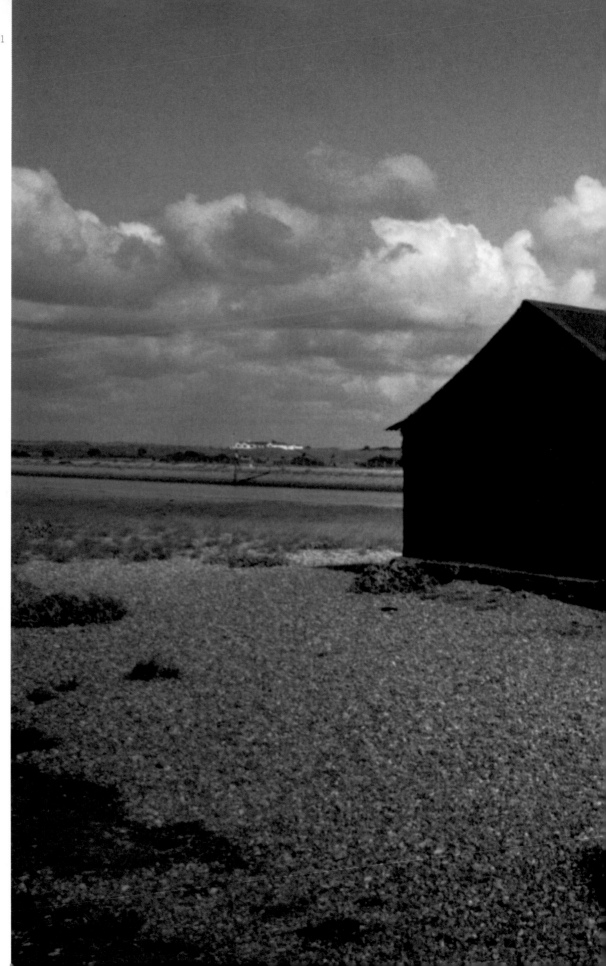

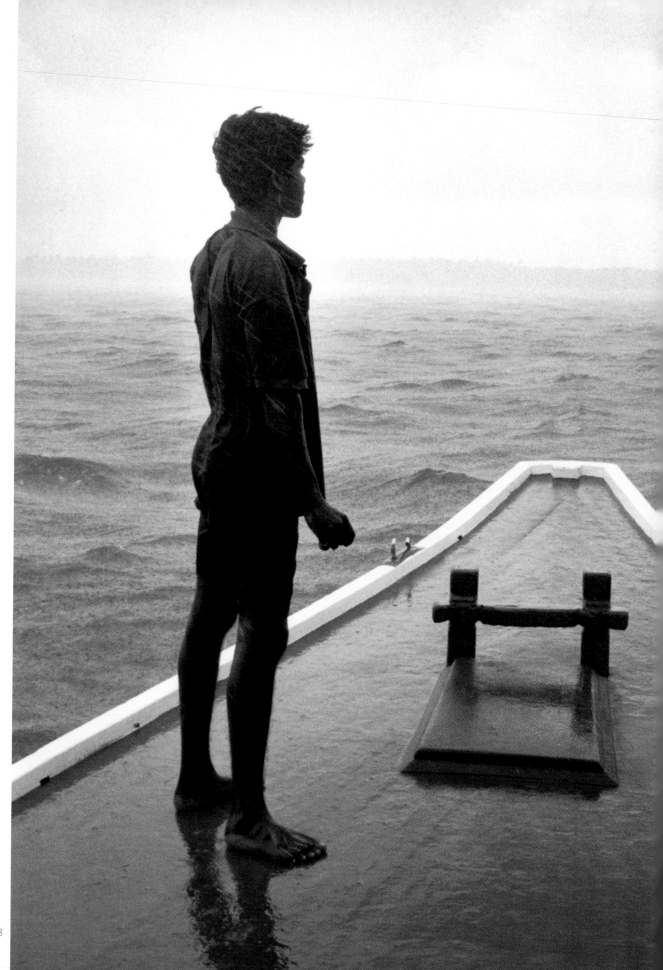

Maldives, 1998

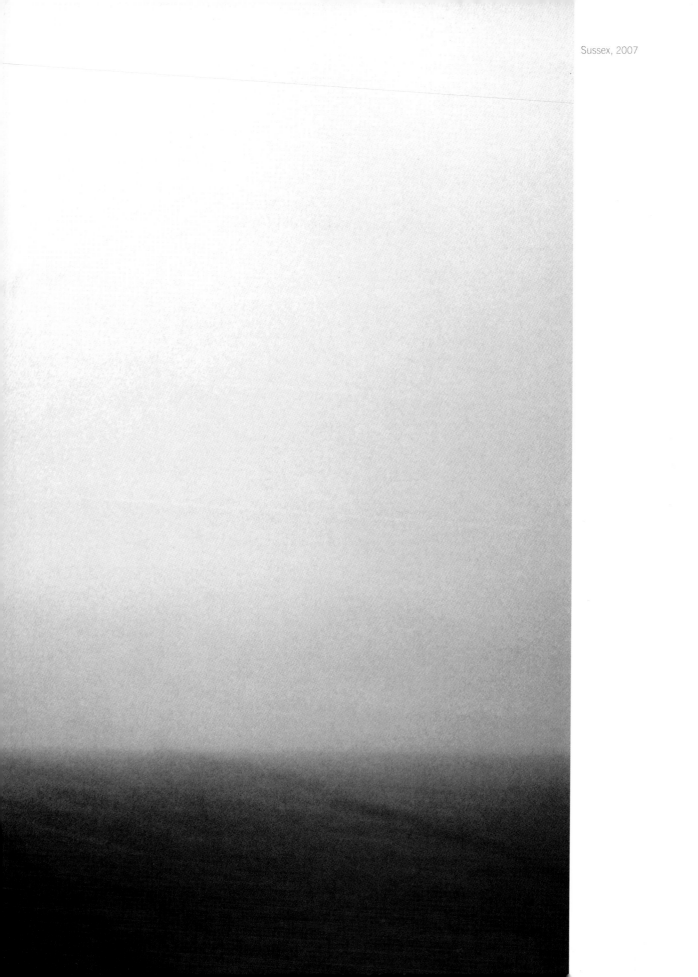

Sussex, 2007

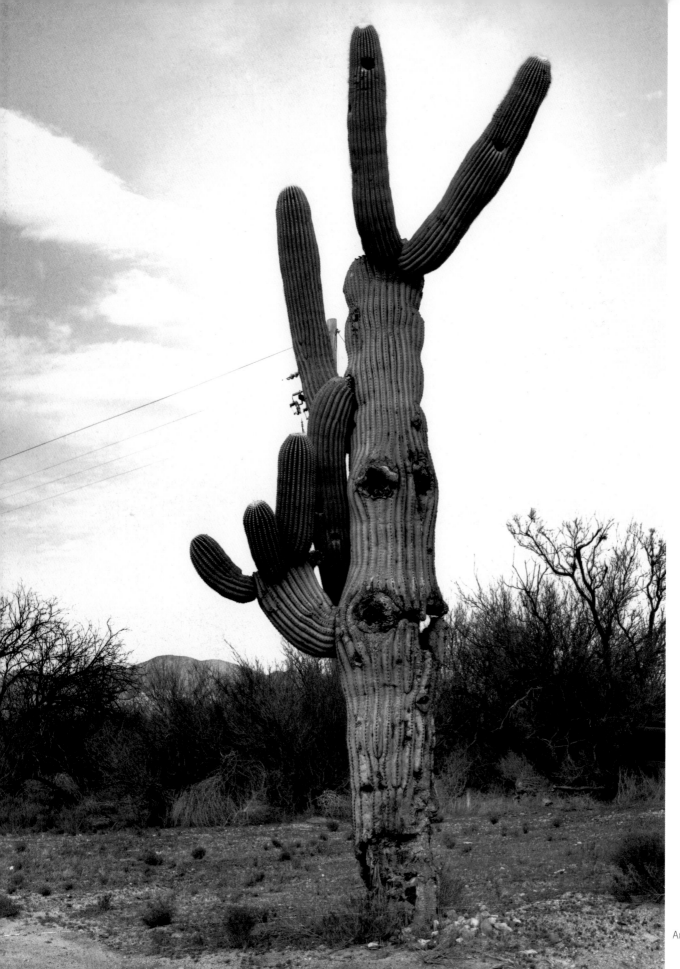

Arizona, 2003

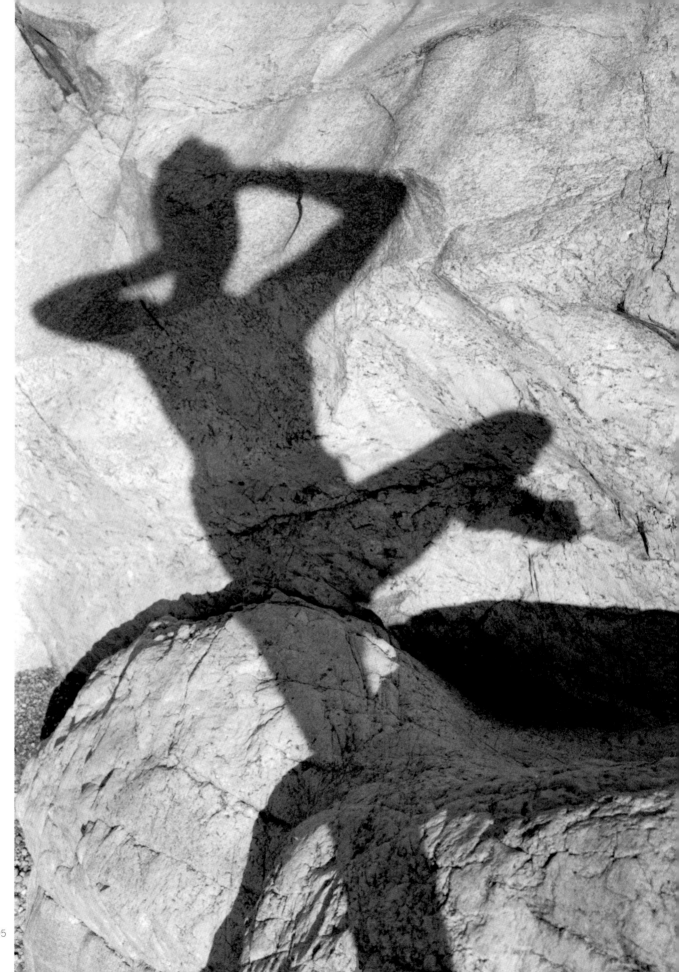

Arizona, 1995

Acknowledgments

Simon Aboud, Dad, Hettie, Stella, James, Arthur, Elliot, Sam,
Samantha Beckett, T&H team, Abrams team, Mark Holborn,
Caroline Cortizo, Peter Guest at The Image, Sean Mulcahy,
Steve Macleod, Metro Imaging, Lee Eastman, Natalie Doran,
Laurence Vuillemin, Kenny Burns, Michael Hoppen, Alex Foreman,
Tracy Le Marquand, Ben Warren, Catherine Naylor Leyland,
Shoemakers Elves, Jane Bradley, Lucy Halperin, Teresa Armitage,
the Royal Opera House, Lucy Yeomans, Brian Clarke, Sir Frank Lowe,
Sir Peter Blake, Chrissie Blake, Chrissie Hynde, Lauren Levine,
Robby, Elaine, Bo, Johnny Blue Eyes, Taz Darling, Steven Fisher,
Etty Bellhouse, Gawain Rainey, Holly Scott Lidgett,
Josh Olins, Zoe Norfolk, Kasia Zdanowska, Anna Su.